LITTLE BOOK OF

GIVENCHY

Published in 2023 by Welbeck
An imprint of Welbeck Non-Fiction Limited
part of Welbeck Publishing Group
Offices in: London – 20 Mortimer Street, London W1T 3JW &
Sydney – 205 Commonwealth Street, Surry Hills 2010
www.welbeckpublishing.com

A CIP catalogue record for this book is available from the British Library.

ISBN 978-1-78097-277-0

Printed in China

10 9 8 7 6 5 4 3 2

LITTLE BOOK OF

GIVENCHY

The story of the iconic fashion house

KAREN HOMER

WELBECK

CONTENTS

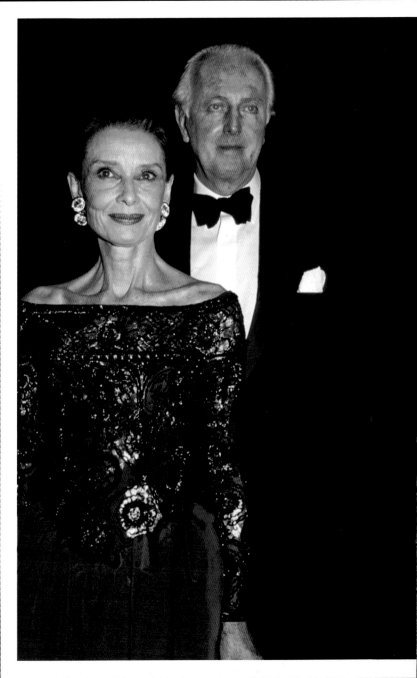

INTRODUCTION

"The dress must follow the body of a woman, not the body... the shape of the dress."
– Hubert de Givenchy

Hubert de Givenchy is one of only a handful of fashion designers who have changed the way women feel about themselves, their bodies and the clothes they wear. Throughout his life, he managed to uphold his own design integrity while embracing contemporary style. He changed the rules of fashion, in the early days of his career, when he rebelled against waistlines in favour of the balloon silhouette, and over the years to follow.

Along with his friend, mentor and fellow couturier Cristóbal Balenciaga, Givenchy allowed women to begin to relax in their clothes, offering welcome relief from the rigid structures of 1950s clothes.

OPPOSITE Audrey Hepburn and Hubert de Givenchy remained close friends throughout their lives. Pictured here at the Waldorf Astoria Hotel in New York in 1991, Hepburn wearing a stunning off-the-shoulder pink gown with sequinned bodice.

The son of a marquis, brought up in an artistic upper middle-class household, he was passionate about fashion from a young age. In 1952, and at the age of just 25, he opened his own haute couture salon in Paris. His career spanned more than four decades. Givenchy will forever be linked to his greatest muse, and close friend, Audrey Hepburn. His designs for the films in which she appeared, including *Sabrina*, *Funny Face* and *Breakfast at Tiffany's*, are some of the most memorable in Hollywood costume history. Givenchy also dressed a celebrity roll call of actresses and socialites, from Grace Kelly to the Duchess of Windsor. He created signature outfits for 1960s style icon Jackie Kennedy when she was First Lady of the United States, including the black suit and pillbox hat she wore to the funeral of her husband, the 35th president John F Kennedy.

Since Hubert de Givenchy's retirement in 1995, the artistic direction of the fashion house has passed through the hands of several imposing names in contemporary fashion design, including John Galliano and Alexander McQueen. However, it was the arrival of Riccardo Tisci in 2005 that brought Givenchy to a new audience. Embracing the possibilities of streetwear, Tisci transformed not only womenswear but menswear too, making the house of Givenchy a major player in the high-end fashion landscape once more.

Most recently, Matthew Williams has continued to push the boundaries of the brand, creating a street-luxe Givenchy universe that encompasses social media, celebrity endorsement, music and savvy marketing. Despite the huge differences in their aesthetics, Williams, like Givenchy, is an instinctive fashion designer, his designs demonstrating a beauty that reflects on the wearer.

OPPOSITE Givenchy's first muse, the stunning model Bettina Graziani, was photographed wearing a black strapless gown for his Spring/Summer 1952 collection. The sculptural hat, pearl necklace and earrings finished the look with Givenchy's trademark sophisticated elegance.

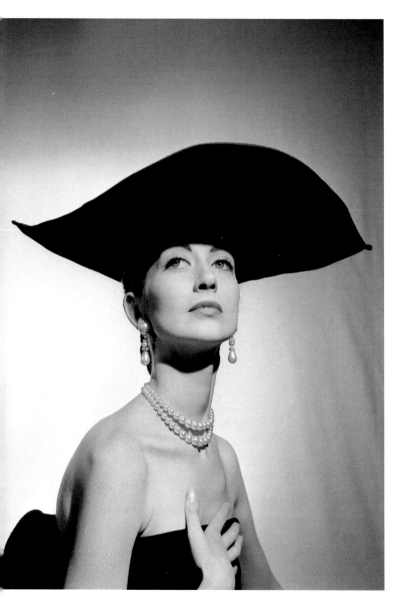

EARLY YEARS

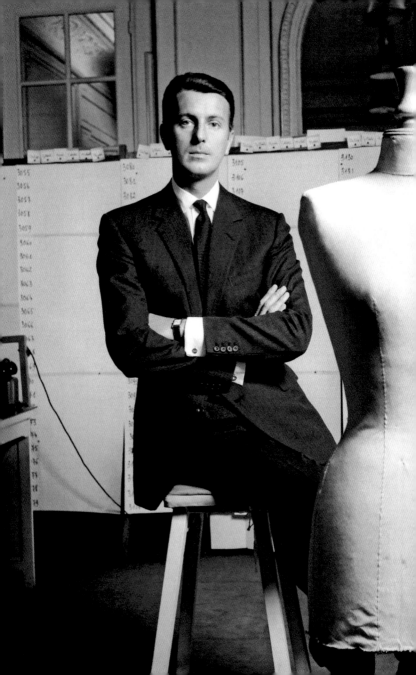

A BORN COUTURIER

Count Hubert James Marcel Taffin de Givenchy was born in
Beauvais, northern France, in 1927.

His father was an aristocrat, while his mother's side of the
family included several generations of artists. Givenchy was
descended from set designers for both the Paris Opera and the
Élysée Palace. His grandfather, Jules Badin, was an artist who
was trained by the painter Jean-Baptiste-Camille Corot and
eventually became the manager of the prestigious Gobelins and
Beauvais tapestry manufacturers.

When Givenchy was a small child, the death of his father
from influenza tipped the balance towards an artistic upbringing.
The young Hubert was raised by his mother, Beatrice, known as
"Sissie", and his maternal grandmother. He was immersed in a
bohemian environment, where creativity was highly valued, and
his interests flourished. The feminine influence of his caretakers
may have been instrumental to his future success.

Givenchy's grandfather was passionate about fabrics and
textiles and boasted a collection of clothes from cultures around
the world. This collection sparked Givenchy's love of fashion,

OPPOSITE Fashion designer Hubert de Givenchy,
displaying his trademark distinguished and aristocratic
bearing, is pictured next to a dressmaker's dummy in his
atelier in 1960.

further developed on a memorable visit to the 1937 World's Fair in Paris, where visitors could admire the work of designers such as Lanvin, Chanel and Schiaparelli. Family lore maintained that the 10-year-old Givenchy even tried to run away from home to meet his idol, Cristóbal Balenciaga.

Givenchy's mother helped her young son access the world of high fashion by allowing him to accompany her to the Paris couture houses. She always wore clothes of exquisite quality, seeking out beautifully crafted garments made of sumptuous fabrics. Later, the designer recalled: "I would beg her to let me see and feel those wonderful materials."

At home, Givenchy sketched dresses prompted by these outings and inspired by the models in his mother's fashion magazines. As he told *W* magazine in October 1979: "At nine, I made a little box which was a copy of what dresses [were] delivered in from a grand fashion house."

As well as fuelling his obsession with fashion, Givenchy's mother raised him with the impeccable manners expected of a young man from a haute bourgeois background. This apparently effortless charm – which Givenchy exhibited at a precociously young age – combined with his ease in the company of high society women, became part of his appeal as a couturier. The Frenchman was six feet six inches tall, and his unusual height added to the good impression given by his handsome appearance and aristocratic manner. Add impeccable style, and it's no wonder that throughout his life Givenchy was both highly regarded as a fashion designer and keenly sought-after as a social companion.

Though Givenchy's mother is said to have hoped her son would become a lawyer, it seemed inevitable that he would pursue a career in couture. He left school aged 16 and went on to study art at the École des Beaux-Arts. Givenchy's first

OPPOSITE A poster advertising Chanel's fashion in 1937. Along with Lanvin and Schiaparelli, Chanel was a particular draw for the young Givenchy when he visited the World's Fair in Paris, sparking his interest in fashion.

Modes & Travaux

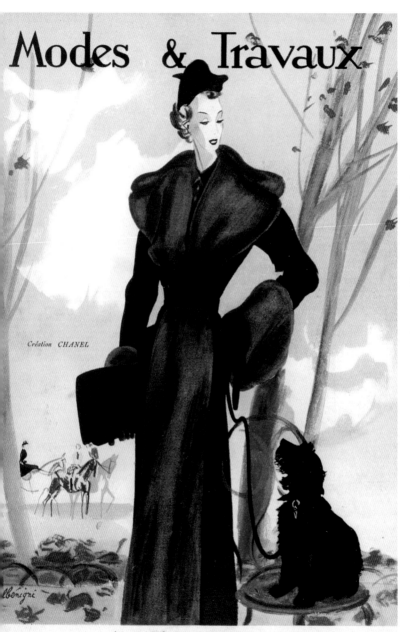

Création CHANEL

ÉDITIONS ÉDOUARD BOUCHERIT

Colonies : **5 francs**

10, rue de la Pépinière, Paris.

apprenticeship was with the couturier Jacques Fath in 1945. The youthfulness and suggestive quirks that Fath brought to the staid world of haute couture had a lasting influence on Givenchy, who for the rest of his career brought a quality of playfulness to his designs. In an interview for the book *Vogue on Hubert de Givenchy*, he described the working environment as

'a haven of fun and fantasy… the atmosphere completely captivated me. Entering Jacques Fath's fashion house was like stepping into a universe of danger and sensuality."

After a year with Fath, on the recommendation of the then-fledgling fashion designer Christian Dior, Givenchy moved first to Robert Piguet and then briefly to Lucien Lelong. As well as Dior, Givenchy worked alongside the young Pierre Balmain. Both designers revered the architectural aspect of tailoring and combined scrupulous technique with a timeless, sophisticated elegance.

However, it was Givenchy's four years working for the legendary avant-garde fashion designer Elsa Schiaparelli, who promoted him to artistic director, that helped consolidate his taste for classic fashion and his unique sense of modernity.

In an interview with *Women's Wear Daily* in 2014 Givenchy recalled the eccentric fashionista as "a tall lady with her booties, her suit, her hats and her jewellery." Commenting on her "originality and audacity," he drew inspiration from the fact that Schiaparelli was "very modern (at)…a time when nobody believed in couture."

BELOW Givenchy
worked for the
legendary fashion
designer Elsa
Schiaparelli between
1949 and 1951, gaining
valuable experience
which helped his own
aesthetic to develop.
Givenchy recalled that
Schiaparelli was furious
when he left to set up
his own atelier.

Schiaparelli gave Givenchy the confidence to launch his own label, but she was reluctant to let him go. As he recalled, "she was… furious, and told me 'you will go bankrupt.'"

Nevertheless, in 1952, Givenchy fulfilled his childhood ambition and opened an eponymous fashion house on rue Alfred de Vigny in the 8th arrondissement of Paris. His first collection set the scene for more than four decades of impeccab[le] design with a selection of elegantly structured separates. The collection included blouses and skirts in unusually simple fabrics, such as raw cotton. *Vogue* announced that the collection was "one of the most newsworthy happenings this spring."

BELOW Givenchy worked for the legendary fashion designer Elsa Schiaparelli between 1949 and 1951, gaining valuable experience which helped his own aesthetic to develop. Givenchy recalled that Schiaparelli was furious when he left to set up his own atelier.

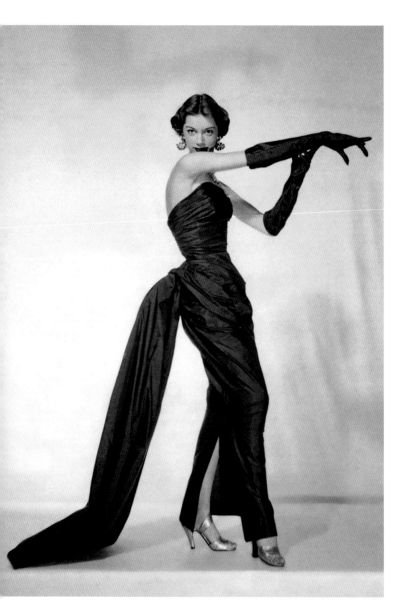

THE HOUSE OF GIVENCHY

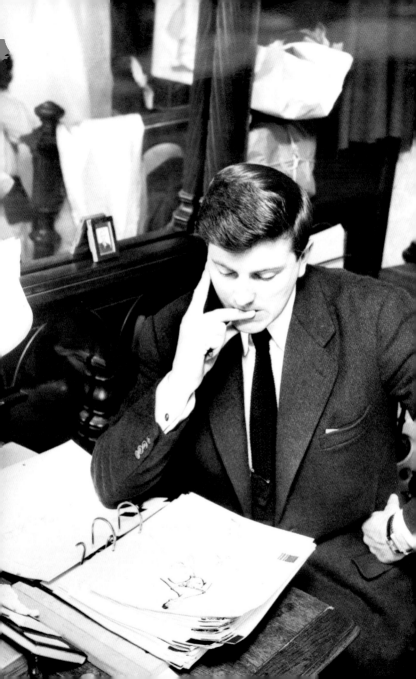

A SALON OF HIS OWN

Givenchy launched his fashion house at number 8, rue Alfred de Vigny, when he was just 25 years old.

Noticeably different in atmosphere from the elite salons of the grand Paris couturiers, Givenchy's tiny atelier buzzed with the excitement of the new. It helped that Givenchy's youthful charm and enthusiasm had secured him a troupe of pretty and vivacious models, including Suzy Parker, Capucine and Bettina Graziani. Graziani was a former Jacques Fath model after whom Givenchy named his first collection. Not only was she his muse but she also proved indispensable as an assistant and press agent. Givenchy's debut was an indisputable success. According to American *Vogue*, the "applause at his premiere was loud, unqualified, and long."

And the presentation was all the more impressive for having been executed in a small, cramped space and on a minimal budget. As *Life* magazine reported: "The dresses were displayed in a show as smoothly elegant as the most experienced house

OPPOSITE The 25-year-old Hubert de Givenchy studying some of his sketched designs shortly after opening his own fashion house on 8 rue Alfred De Vigny in 1952.

in Paris could have put on – in quarters so cramped that last-minute ironing was being done in the bathroom!"

Givenchy had broken with tradition in more ways than one. While other designers created prohibitively expensive couture garments, crafted from ostentatious fabrics, here was a boutique collection of separates that foreshadowed designer ready-to-wear, made not from silks and velvets but from everyday cottons. In a colour palette centred on black and white, Givenchy had created the original capsule wardrobe. His slim trousers, elegant skirts, blouses and neat jackets could all be paired with each other to create a variety of different outfits.

One blouse stood out. Named the "Bettina", it was made from raw white cotton shirting. Classically tailored in the body, it erupted into voluminous ruffled sleeves, which were embroidered with black eyelets and tightly buttoned into long, narrow cuffs.

With traditionally elegant coats and dresses that might have been designed by Dior, Givenchy's collection offered the audience moments of playfulness. A model wearing a classic ballgown turned around to reveal a tiered cape of percale cotton; a babushka headscarf was pleated like a paper lantern. These were early examples of the eclectic twists Givenchy added to his collections throughout his career.

The apparent simplicity of these designs was deceptive. Givenchy was an extremely skilled architect of fashion design who paid meticulous attention to the construction of his clothes. His stylistic approach combined elegant classicism with an awareness of women's comfort: unusual in the heavily corseted world of Paris haute couture. In an interview with Drusilla Beyfus, Givenchy explained: "Trying to make a woman more beautiful is to try to understand her well, for her to be well dressed and above all, comfortable in her clothes. If a woman moves well, her gestures will be natural and she will be happy."

OPPOSITE Givenchy's atelier was small and cramped with chaotic backstage scenes that belied the polished show being presented front of house.

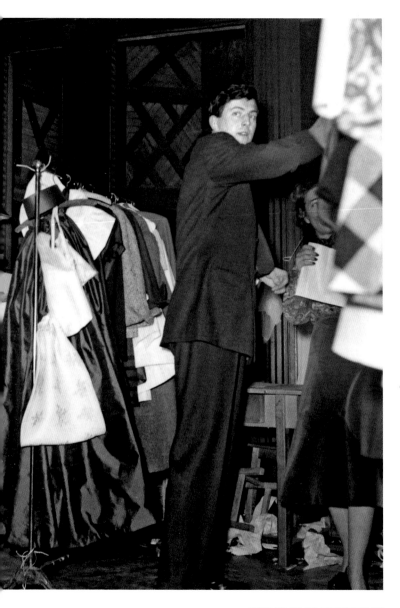

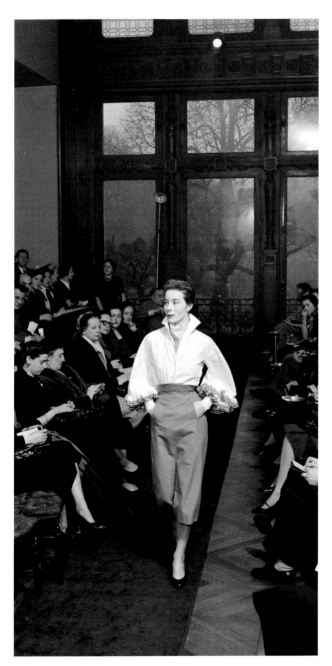

LEFT Givenchy's debut collection was shown to a captivated crowd of onlookers. Pictured here Bettina Graziani, Givenchy's first muse, models her namesake, the iconic white "Bettina" blouse with its distinctive ruffled sleeves finished with black eyelets.

Givenchy's debut collection was an immediate success, with society women clamouring to buy his innovative designs – so much so that the limited resources of the fledgling atelier struggled to satisfy demand.

Over the next few years, the designer aspired to a ready-to-wear business model, continuing to create separates at the centre of his collections. However, an adequate system of production was not yet in place. Copies of his designs by established dress manufacturers appeared in fashion magazines during the 1950s and early 1960s, but until the launch of his Nouvelle Boutique in 1968, Givenchy's clothes were made to order, just like those of any other Parisian couturier. Nevertheless, his collections were always well received, and in 1959 he moved from his cramped atelier to a larger salon on Avenue George V.

Givenchy continued to experiment, creating pioneering designs that became icons of the era, such as his close-fitting hats. In 1957, he launched one of his most memorable designs, the "sack" dress. Adapted from another creation, a voluminous, cocoon-shaped shirt dress, this flattering silhouette was fitted at the shoulders and ballooned gently out around the waist, before elegantly skimming the legs to land just below the knee. It was the opposite of Christian Dior's tightly cinched "New Look" shape that so dominated the fashions of the day – and it was infinitely more comfortable to wear. In 1958, the designer debuted a garment that would become known as the "babydoll" dress. Some critics opined that the loose-fitting design, intended as daywear, made the models look as if they were wearing a toddler's playsuit.

Givenchy's aesthetic was still the height of elegance, but with these new shapes, he could help fashionable women feel relaxed as they went about their day. He declared: "The dress must follow the body of a woman, not the body… the shape of the dress."

The styles were a huge success and had a lasting influence on the fashion landscape.

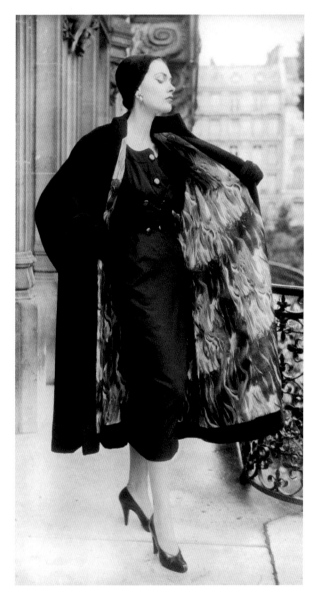

LEFT A classic Givenchy-designed outfit from 1955 comprised a woollen black coat lined with printed silk, worn over a slim-fitting black jersey dress. The matching black skull cap is a signature of Givenchy's pared down elegance.

OPPOSITE Givenchy's designs were an immediate hit. Here model Suzy Parker wears a full, Chinese-inspired lacquered-printed pink skirt for a *Vogue* editorial shoot by John Rawlings in 1953.

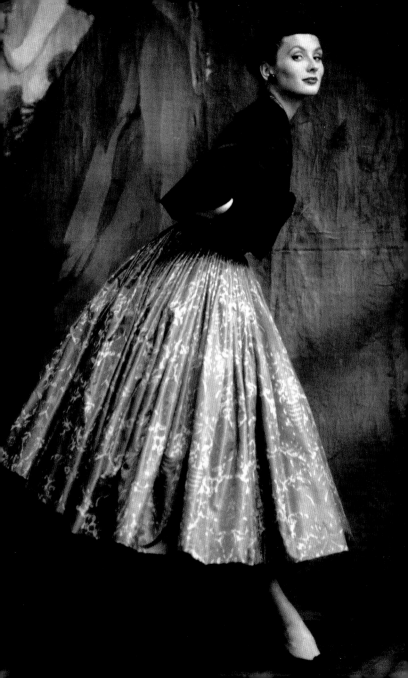

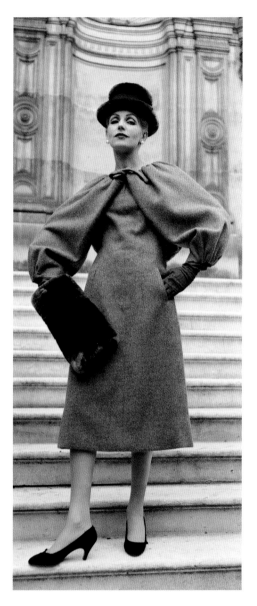

LEFT This 1950s
outfit by Givenchy
of an unstructured
sheath dress made i
grey Shetland wool
with voluminous
bolero sleeves clear
shows Balenciaga's
influence. However,
the controversial
drawstring at the
neck is an unusual
embellishment that
pure Givenchy in sty

CRISTÓBAL BALENCIAGA

It is impossible to talk about Givenchy's trailblazing silhouettes without mentioning Cristóbal Balenciaga, the Spanish designer whom he had idolized since childhood and who later became his mentor. "Balenciaga was my religion," Givenchy told *Women's Wear Daily* in 2007.

> "The elegance and beauty of his clothes and shapes were very different from other designers."
>
> – Hubert de Givenchy on Cristóbal Balenciaga

Givenchy first approached the House of Balenciaga after he left the École des Beaux-Arts, hoping to become an apprentice to the famous couturier, but he was turned away. It was not until 1953 that he finally met the man with whom he would redefine the fashion aesthetic of the late 1950s.

In an interview with Hans Ulrich Obrist for *System* magazine in 1995, Givenchy explained his intense admiration for Balenciaga.

"His exceptional work, his extraordinary career, his creativity, his values and above all, his elegance. When I first met him, I was influenced by his self-belief, his refusal to cheat, his simplicity and his honesty… I was in awe of him. I was fascinated by his meticulousness. He knew how to do everything – cut a dress, assemble it from a pattern. He had worked in London and elsewhere, and had forged his own vision of fashion through which he was able to express his creativity. He allowed me to prove myself and to develop my own ideas and creativity."

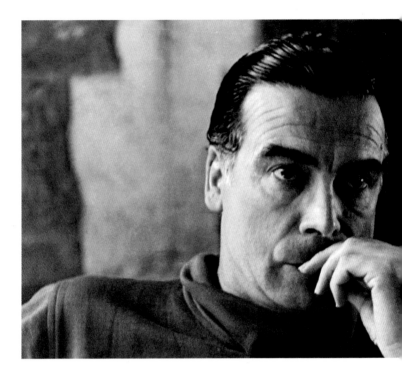

ABOVE Spanish
fashion designer
Cristóbal Balenciaga
in 1952, shortly before
he met Hubert de
Givenchy. Balenciaga
became a mentor to
the younger designer
and the pair shared
an unprecedented
openness regarding
their work, often
creating similar
designs.

Givenchy and Balenciaga's shared creative language was
extraordinarily fluent. Their salons were situated opposite each
other and they exchanged ideas and inspiration. The relationship
between the two men has been likened to that of father and son
but their bond was aesthetic: they were both drawn to clean,
linear designs. The "cone" silhouette, and the sack- and cocoon-
shaped dresses and coats they both favoured, are examples of
this shared sense of style. By the early 1960s, some
commentators were criticizing Givenchy for mimicking
Balenciaga too closely. But in fact, the pair were equally
influential on the fashion scene, described in *Vogue* as "the
world's most prophetic designers".

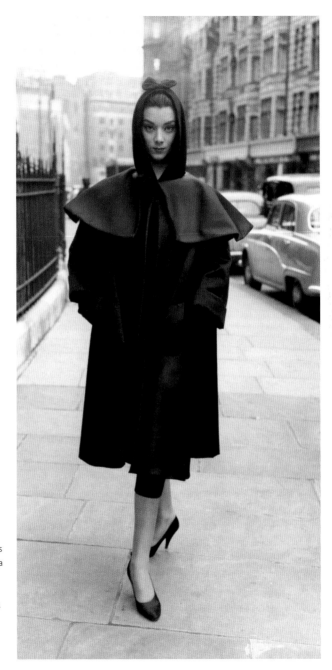

RIGHT Balenciaga influenced Givenchy hugely and during the 1950s both men were credited with changing the fashion silhouette of the day from tightly cinched in to flatteringly voluminous. This dress and coat by Balenciaga from 1955 could just as easily have been designed by Givenchy.

Both designers sought to imbue their clothes with the freshness of youth without sacrificing the elegance and refinement of classic couture. One approach to achieving this was their use of new and innovative fabrics. They were masterful tailors who excelled at creating deceptively simple clothes, elevated by their perfect cut. Feminine touches were important, especially for Givenchy.

Givenchy's most revolutionary designs were the Sabrina or bateau neckline, a wide neckline that cut across the collarbone, popularized by Audrey Hepburn's 1954 film, and his series of shift dresses that skimmed the body, rather than clinging to it. As Dana Thomas wrote in the *Washington Post* in 1995: "His clothes moved with a woman's body, rather than restricting it."

But perhaps the most lasting effect on the fashion world for which Givenchy and Balenciaga were responsible was the relaxed element that crept into their designs in the 1950s and '60s. In the clothing they created, the formal construction and strict lines of the 1950s gradually began to soften, a trend that was adopted, among others, by the houses of Dior and Chanel.

READY-TO-WEAR

In 1968, the same year that Balenciaga closed his salon, Givenchy finally realized his dream of producing luxury ready-to-wear. The launch of his Nouvelle Boutique, at 66 Avenue Victor Hugo, embodied his vision of a luxury shop where a woman could buy separate pieces and build her own cohesive look. Customers and the fashion press alike loved the concept. American *Vogue* featured Hollywood stars such as Marisa Berenson (the granddaughter of Givenchy's inspirational early employer Elsa Schiaparelli) modelling the youthful styles, which featured culotte trousers, neat sweaters and elegant coats. The collection even included a surprisingly sophisticated

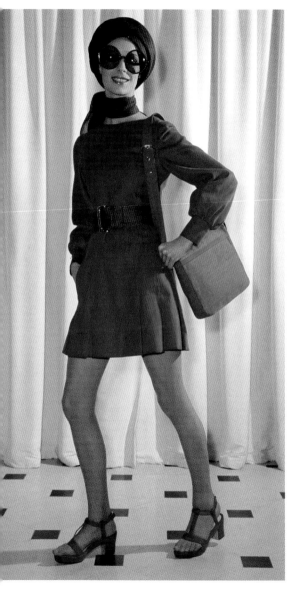

LEFT In 1968 Givenchy launched his ready-to-wear collection which focused on more youthful outfits, often in modern fabrics. This denim minidress with matching bag and shoes and contrasting red belt, turban and oversized sunglasses from 1971 is a typical example.

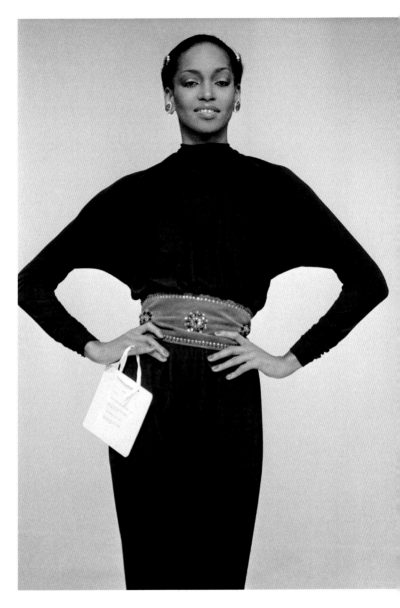

denim button-through dress which *Vogue* proclaimed to be the "blue denim dress everyone wants this summer."

Alongside ready-to-wear, Givenchy continued to produce his couture collections, filled with perfectly cut, luxurious modern classics. As Susan Train, American *Vogue's* legendary Paris Bureau chief, wrote of the designer: "Givenchy held true to his own standards of sophisticated elegance and a totally polished, turned out style of dressing."

In the 1970s, Givenchy chose five Black house models, sending a prescient message about diversity to the fashion world. The Parisian designer has always been willing to walk his own path. When asked about his choice of models in 1979, by André Leon Talley for *WWD*, he said only: "I love the way American mannequins move. Their gestures are marvellous. It makes a whole difference in showing a dress."

DESIGN INFLUENCES

Today Givenchy is often viewed as one of the great traditionalists of French haute couture, renowned for his mastery of the all-black outfit, but from his early years as a designer he drew upon a wide range of influences.

As a designer who was immersed in the classic art of Parisian haute couture, Givenchy naturally drew on European decorative traditions. He had a collector's passion for seventeenth- and eighteenth-century French art. But he was also enamoured of the rich patterns and colours of India and the silhouettes of Middle Eastern robes and Chinese kimonos, which spoke to his love of voluminous shapes. He sometimes topped off his couture outfits with turban-style hats. He was inspired by historical fashions, too, reworking the medieval tabard for the twentieth century. Increasingly successful in the United States, Givenchy found an eclectic source of inspiration in the avant-garde vintage

OPPOSITE Givenchy was a rare designer who, as early as the 1970s, chose Black house models, many of whom were American. This shot is from his Autumn/Winter 1979 collection.

fashion boutique Limbo, a well-known touchpoint of the counterculture, founded in 1965 in Manhattan's East Village. Influenced by the magnificent collections of wealthy American clients such as Jayne Wrightsman and Rachel "Bunny" Mellon, he began to purchase contemporary art, which became another source for his designs. His love of vibrant colour shaped a collection of paintings by artists including Rothko and Miró and his collections were perceptibly influenced by the paintings of Matisse and Raoul Dufy.

This immersion in art and culture was a major influence on Givenchy's fashion designs throughout his career. In 2012 he told Susan Moore, a writer at the art magazine *Apollo*: "What I try to achieve is principally a harmony between architecture, decoration and colour."

It was Givenchy's devotion to decorative details that distinguished him most from Balenciaga. The lines of his clothes are rescued from severity by his use of embroidery, *passementerie* (ornamental trimmings) and bows of all sizes. Pockets and belts are transformed from functional elements into eye-catching features. The manipulation of scale is a trick frequently used by Givenchy, especially in his oversized collars, scarves and stoles, which softened the appearance of his tailored creations.

Givenchy also favoured animal prints, and throughout the 1960s and 1970s his clothes were a riot of zebra, leopard and giraffe. He was devoted to fur, although unusually for a designer of his generation, he began using imitation mink, beaver and fox in the early 1950s.

Like his close friend and muse, Audrey Hepburn, Givenchy was a passionate lover of flowers and plants, and these too often appear on his designs. Other motifs that he took from nature included palm trees and fruit. His playful approach

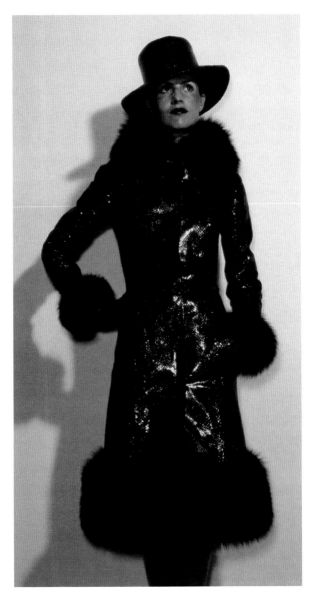

RIGHT Givenchy
often used animal
prints in his designs
such as this fur-
rimmed red coat
with a snakeskin print
offset with a matching
hat from Autumn/
Winter 1973.

to pattern and print led him to develop the eighteenth-century obsession with decorative pineapples into a fruit salad of strawberries, grapes, oranges and lemons. On one memorable summer dress he even foregrounded slices of tomato. Somehow, the end result avoided kitsch to achieve an unexpected sophistication.

Givenchy had an unerring eye for fabric. The fashion writer Catherine Join-Diéterle described the precision of his taste:

"He sees fabrics with the eyes of a painter and sculptor, admiring the motifs, shades, texture, quality and fall."

Givenchy's preoccupation with what textiles could offer was somewhat unusual in a couturier of his era. His peers usually dreamed up a design first, then chose luxurious cloth in which to make it. But his approach was in keeping with his obsession with the way clothes moved on the body, as he explained to *Vogue*: "The fabric is the thing that inspires you first. Then comes the creation (of the design) and knowing how to give the fabric its best possible value."

Beginning with the cotton shirting he used in his first collection, and throughout his career, he carefully sought out fabrics to inspire his designs. From the 1980s onwards, technological developments in fabric production allowed him to give free rein to the more theatrical side of his design personality.

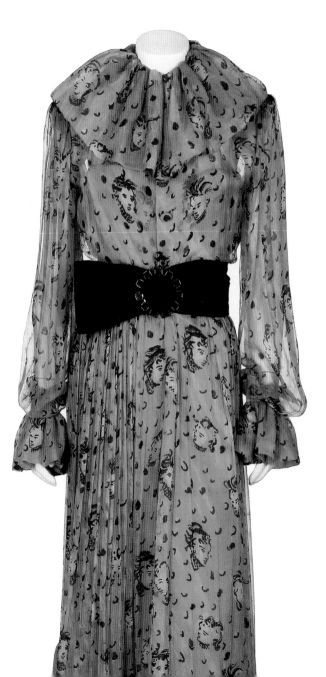

RIGHT The quality of fabric and the appeal of striking prints was often the jumping-off point for Givenchy's designs. This orange couture chiffon gown (with Christian Bérard print) from his Autumn/Winter 1987 collection is a typical example.

THE
ULTIMATE
MUSE

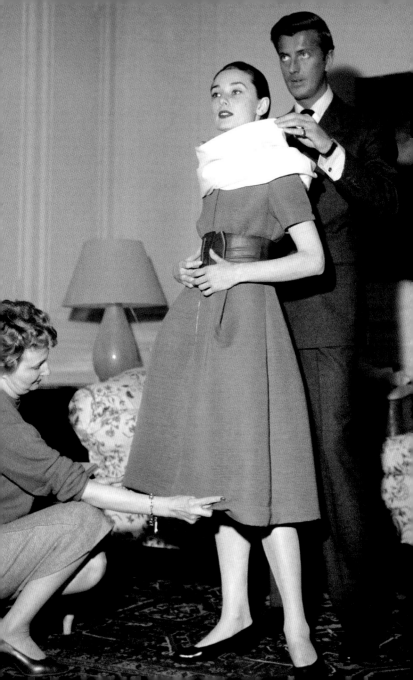

AUDREY HEPBURN

"His are the only clothes in which I feel myself. He is far more than a couturier, he is a creator of personality."
— Audrey Hepburn on Hubert de Givenchy

Givenchy's most iconic clothes are inextricably linked with the enduring style of his greatest muse, the actress Audrey Hepburn. Her gamine looks suited his silhouettes perfectly, and early in both their careers Givenchy and Hepburn became each other's inspiration. Their working relationship developed into a lifelong close friendship.

The pair met in 1953, when the newly successful Hepburn was sent to Paris to find stylistic inspiration for her eponymous role in the film *Sabrina*. Over the course of the film, Hepburn's character is transformed from the gauche daughter of a chauffeur into a sophisticated young woman after spending two years studying in the capital.

Givenchy later admitted that he had been expecting the established actress Katharine Hepburn to appear in his salon, and not, as he put it in an interview with *Vanity Fair* magazine:

OPPOSITE From the earliest days of their working relationship, Givenchy admired Hepburn's elfin physique and exquisite appearance, devoting many hours to dressing her. He is shown here trying out shapes on the actress in 1958.

"This very thin person with beautiful eyes, short hair, thick eyebrows, very tiny trousers, ballerina shoes, and a little T-shirt. On her head was a straw gondolier's hat with a red ribbon around it that said 'Venezia'. I thought, 'This is too much!'"

Hepburn wanted Givenchy to design some costumes for *Sabrina*, but with the designer's new collection due imminently, this was impossible. Nevertheless, Hepburn was determined. In an interview at the opening of a 2016 exhibition to celebrate the relationship between the pair the designer recalled:

"I was busy preparing my next collection so I told her I wouldn't be able to do it, but she was very persistent. She invited me for dinner, which was unusual for a woman to do back then, and it was at dinner that I realized she was an angel."

Still too short of time to create unique designs for *Sabrina*, Givenchy was sufficiently charmed by Hepburn to allow the actress to try on clothes from his recent spring collection. She picked out three outfits which became standout looks for the film.

SABRINA

The first Givenchy outfit that Hepburn wore in the film was for the scene which revealed Sabrina's transformation on her return from Paris. The young woman who emerges from the train station is the epitome of French chic, wearing an elegant, slim woollen suit, deceptively simple, but scrupulously cut. The Oxford grey wool ottoman has a collarless double-breasted

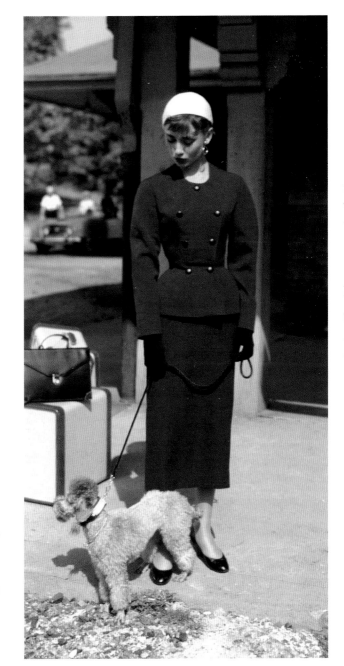

RIGHT The first outfit that Audrey Hepburn wears in *Sabrina* is a slim and elegant Oxford grey wool-ottoman suit with a collarless double-breasted jacket, cinched at the waist into a fashionable peplum style.

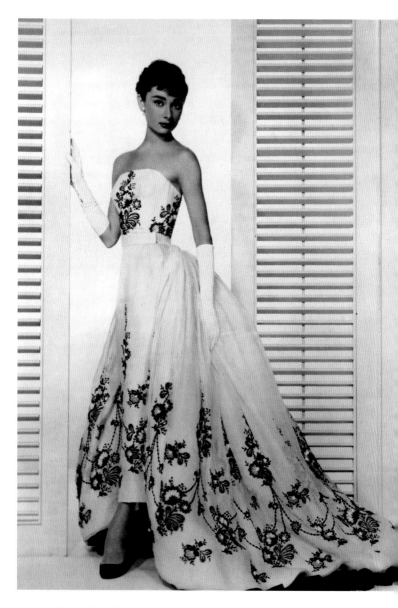

jacket, cinched at the waist into the peplum style that was so popular during the 1950s, and a long, narrow, vented skirt. It is accessorized with hoop earrings and a close-fitting pearl-grey chiffon turban, also from Givenchy's collection.

It was a beautifully appropriate outfit for this particular character to wear in this particular moment, and it's hard to think of a more suitable model for the garments. When Givenchy described to *Vanity Fair* his reaction when Hepburn first tried on the suit, it sounds as though he's describing the transformation of Sabrina herself.

"The change from the little girl who arrived that morning was unbelievable. The way she moved in the suit, she was so happy. She said that it was exactly what she wanted for the movie. She gave a life to the clothes."

The second of Givenchy's designs to be used in the film was a dramatic strapless ballgown made from white organdy – a semi-sheer, structured yet delicate cotton. Its proportions seem to inspire Sabrina's ecstatic on-screen description: "I have an evening dress just for the occasion… yards of skirt and way off the shoulders!"

Its bodice and skirt were adorned with a floral motif in black silk embroidery and jet beading. The dress was completed with a detachable train, trimmed with a black organza ruffle.

The final *Sabrina* outfit was a knee-length black satin cocktail dress. With its tiny waist, flared skirt, and high, straight neckline, finished with a distinctive tied-bow detail at the

OPPOSITE The iconic strapless ballgown was made from white organdy and adorned across the bodice and skirt with a floral motif in black silk embroidery and jet beading.

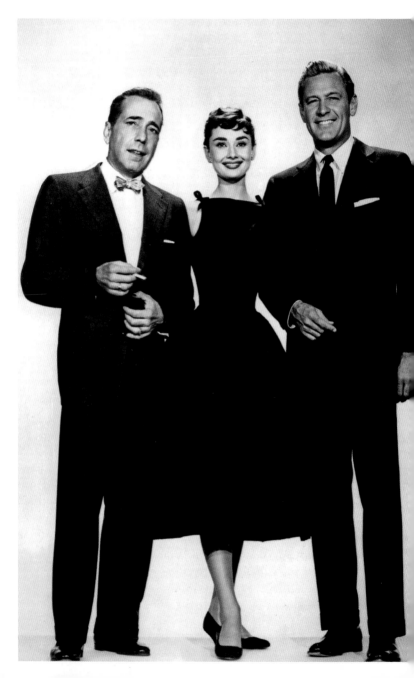

shoulders, it suited the actress to perfection. Hepburn picked out another of Givenchy's trademark skull-hugging caps, a neat black number embellished with rhinestones, to finish the look. The dress's high "bateau" neckline was a favourite of Hepburn's as it hid her collarbones, which she felt were unattractively skinny. The design was much copied and had such an impact on fashion that the neckline became known as the "décolleté Sabrina."

Sabrina marked the beginning of a long collaboration between Givenchy and Hepburn where costume design was concerned. But this first contribution by the designer went unacknowledged, sparking controversy. Edith Head, Hollywood doyenne of costume design, and head of costume at Paramount Pictures since 1938, took credit for the "Sabrina" looks. She insisted that she had designed the black cocktail dress herself, accepting an Oscar without even thanking Givenchy.

Although he was clearly annoyed by Head's refusal to acknowledge his input on *Sabrina*, Givenchy, ever the gentleman, diplomatically agreed that the garments in question, along with the doubles and trebles required for filming, had come out of the studio workshops. But what was never in doubt was that they were copied directly from his own original designs. Any adaptations specifically for *Sabrina* were made with Givenchy's input. For example, the white ballgown originally had a black bodice, which was altered to make the dress more appropriate for a summer ball.

Head's desire to take credit for Sabrina's costumes was perhaps understandable. In her 1983 memoir, she recalled her excitement when the project was first revealed: "Every designer wishes for the perfect picture in which he or she can really show off design magic. My one chance was in *Sabrina*… It was the perfect setup. Three wonderful stars, and my leading lady looking like a Paris mannequin." Audrey Hepburn, however, was appalled. The actress, who was already fond of Givenchy and enamoured of his

PPOSITE Audrey
epburn flanked by
er *Sabrina* co-stars
umphrey Bogart and
'illiam Holden. The
ted knee-length,
ack satin cocktail
ess featured a
ateau" neckline with
licate bows on each
oulders that became
popular it was
hamed the "Sabrina"
ckline.

creations, was furious that he had not been credited in any way for *Sabrina*. When the pair collaborated again on *Funny Face*, she insisted that Givenchy be credited alongside Edith Head.

FUNNY FACE

For *Funny Face*, in 1957, Givenchy was given full credit for "Miss Hepburn's Paris Wardrobe," and the outfits he created were breathtaking.

As in *Sabrina*, the premise of the film bears a distinct resemblance to the story of Cinderella. Hepburn plays a young, bookish woman, Jo Stockton, who is plucked from her job in a Greenwich Village bookstore to be transformed into the face of *Quality* magazine, a fashion bible for whom she is to model the latest Paris trends.

The film is a musical and Audrey Hepburn's co-star is the star cinematic dancer Fred Astaire. He plays Dick Avery, a fashion photographer who plucks Jo Stockton from obscurity, flies her to Paris and along the way, falls in love with her. The ensuing romp makes for a wonderfully uplifting film, which the *New York Times* reviewed enthusiastically:"The eye is intoxicated with exquisite colour designs and graphic production numbers that are rich in sensory thrills."

Hepburn was a trained dancer who had once aspired to become a professional ballerina, so collaborating with Astaire was the actress's dream come true. However, the other source of *Funny Face's* appeal was the opportunity it offered for her to indulge her self-confessed love of fabulous clothes.

Givenchy and Hepburn were given free rein to create the most exquisite wardrobe imaginable. To this day, the outfits from *Funny Face* retain an almost contemporary chic, testament to the timelessness of Givenchy's designs.

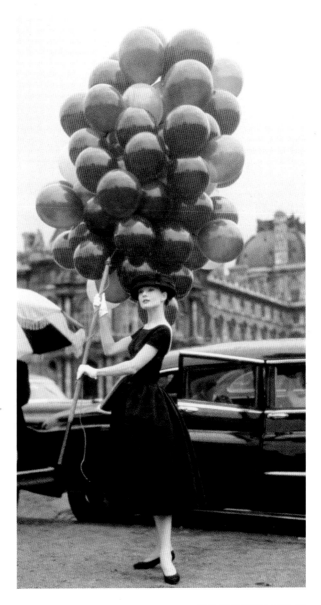

RIGHT Audrey
Hepburn wears
another Givenchy
black cocktail dress
with a boat neckline
in *Funny Face* for
the scene where she
releases a flock of
colourful balloons
outside the Tuileries
Palace. This was her
favourite neckline, as
she felt it covered her
unattractively skinny
collarbones.

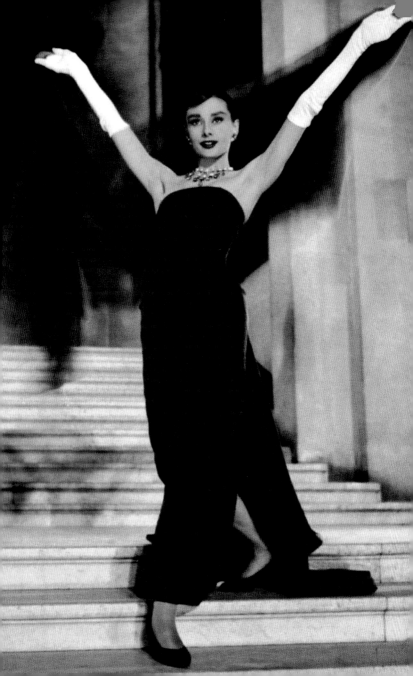

When Jo Stockton's transformation is first revealed, the shopgirl-turned-model appears wearing a long champagne satin dress, topped by a pink cropped jacket with its own long train, and styled with a beaded headdress. The vibrancy of the pink is offset by the simple elegance of the cut, once again the perfect complement to Hepburn's frame.

Several more gowns appear, always crafted to flatter Hepburn's tiny waist and accentuate her elegant shoulders. The straight, high Sabrina neckline is a key feature of two dresses: the black dress Hepburn wears in the scene shot in the rain outside the Tuileries Palace, as she clutches a fistful of colourful balloons, and her dazzling wedding dress. The epitome of Givenchy's style ethos, with its tiny waist, full skirt, slashed neckline and surprising mid-calf length, the bridal gown was an instant fashion hit.

Other eye-catching outfits include a floral-print day dress accessorized with a large straw hat that Jo wears to the flower market; a classically chic bouclé wool travelling suit; and a white cropped top and matching pair of slim trousers, with bright pink accents on the sash, hat and ballerina pumps. One of the film's most enduring scenes features Hepburn in a long, strapless red silk gown with matching chiffon wrap, skilfully dancing down the steps of the Louvre art gallery, her arms held aloft in celebration.

Although it might be said to be the least "designed" outfit of the film, perhaps the look that is most associated with Audrey Hepburn – in part because it appeared on the promotional posters – was the beatnik-style combination of black fitted top and slim trousers, paired with white socks and black loafers, in which the actress dances around the café.

Funny Face's final fashion show, in which Jo Stockton models solo, proved an opportunity for Hepburn to put even

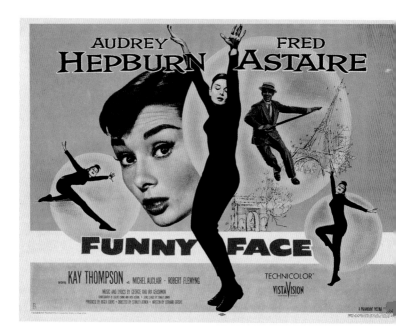

ABOVE As a trained dancer, Audrey Hepburn was in her element in the musical *Funny Face*. Perhaps the most iconic image from the film is the actress in this beatnik style combination of black slim trousers and fitted polo-neck teamed with black loafers.

more of Givenchy's sublime dresses and suits in the spotlight, all immaculately accessorized. The film received an Oscar nomination for best costume design.

LOVE IN THE AFTERNOON

1957 also saw Audrey Hepburn and Givenchy collaborate on *Love in the Afternoon*. Acting the part of Ariane, a music student, Hepburn once again shone in a selection of the designer's outfits. One high point is a classic black Givenchy dress, tight waisted and flaring to tea-gown length, its scooped neck accessorized by a large bow. Another delicious fashion moment is a jewel-encrusted, full-skirted white gown, which Ariane wears to the opera. In keeping with Hepburn's role, her costumes suggest youthful sophistication rather than glamour, but

Givenchy did manage to include a voluptuous white fur coat, the height of decadence.

The outfits in the film play on timeless themes in Givenchy's design vision. A long printed dress features both his signature boat neck and his favourite decorative bows. A tailored wool trouser suit and delicate floral printed gown are both finished with simple white gloves. Another casual, yet impeccably pulled together look, worn for a picnic scene, comprises a simple white blouse, cropped stripy trousers and a red sash. Hepburn's hair is tied in bunches with red ribbons. The colourful accents are typical of Givenchy's style.

BELOW For the romantic picnic scene in *Love in the Afternoon* Givenchy designed a playful red-and-white 1950s look.

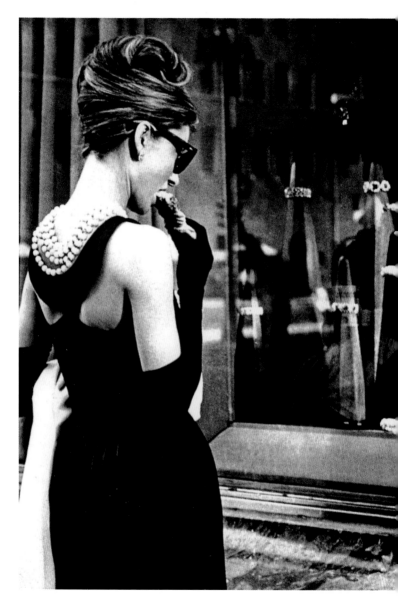

BREAKFAST AT TIFFANY'S

The role for which Audrey Hepburn will always be recognized is her performance as Holly Golightly in the 1961 film *Breakfast at Tiffany's*. The opening scene, in which Holly gazes wistfully into the window of her beloved store, has gone down in costume history, showcasing what must be Hollywood's most iconic Little Black Dress.

The black column gown is made from Italian satin and features a high neckline. When Holly turns, she reveals a scooped cutaway detail. It continues down into a closely fitted bodice, slightly gathered waistline and full-length skirt. Givenchy had originally designed the dress with a split up the side but Paramount Pictures decided that this was too revealing, so a closed version was made for the film. Accessorized with ropes of pearls, full-length black satin evening gloves, a tiara and oversized sunglasses, it is one of few outfits in the history of cinema to become instantly iconic.

The version of the dress that had been adapted for filming was later destroyed but Givenchy kept two originals, one of which was sold by Christie's in 2006 for $807,000, the proceeds going to the charity City of Joy Aid.

But the Little Black Dress was just one of many fabulous costumes designed by Givenchy for the hedonistic and glamorous Holly Golightly. The film features a second little black dress, sleeveless, with a scoop neck, made from black cloqué fabric, and finishing at the knee in a deep fringe. Worn with an oversized hat tied with a large pale scarf, oversized earrings and the ever-present sunglasses, this outfit is the height of style. Holly wears it to visit Sing Sing prison, and for a party, where she matches it with a black Givenchy hat decorated with a black and white feather puff.

Other outfits Givenchy gives to Holly include a sleeveless, textured gown in hot pink, and a stunning double-breasted

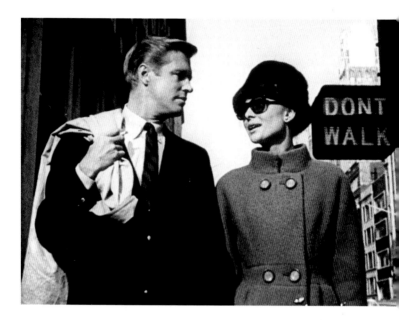

ABOVE This double-breasted orange wool coat from *Breakfast at Tiffany's* features Givenchy's signature stand collar. It is worn over a brown tweed dress and paired with a mink hat.

orange wool coat with a stand collar and three-quarter sleeves, worn over a brown tweed dress and paired with a mink hat.

Givenchy's designs fit seamlessly into *Breakfast at Tiffany's*, convincing us of Holly Golightly's innate chic. The film demanded a wide variety of costumes, not only those designed by Givenchy but also some which were selected by costume designer Edith Head. These included the oversized man's tuxedo shirt Hepburn wears to sleep in and the off-the-shoulder toga-style dress that Holly supposedly makes from a bedsheet when she is caught on the hop having a bath as guests arrive for her party. Other outfits in the film have spawned generations of style copy cats, including the simple jeans and sweater, paired with a turban, which Holly wears when she sits on the fire escape to her apartment to mournfully sing "Moon River" and the Burberry trench she wears towards the end of the film.

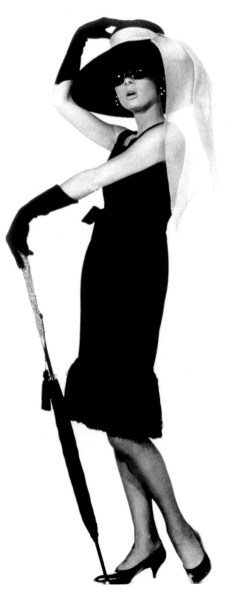

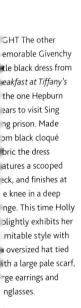

RIGHT The other memorable Givenchy little black dress from *Breakfast at Tiffany's* is the one Hepburn wears to visit Sing Sing prison. Made from black cloqué fabric the dress features a scooped neck, and finishes at the knee in a deep fringe. This time Holly brilliantly exhibits her inimitable style with an oversized hat tied with a large pale scarf, large earrings and sunglasses.

PARIS WHEN IT SIZZLES

In 1962 Audrey Hepburn was once again filming in Paris, this time starring in a romantic comedy, *Paris When It Sizzles*, alongside her *Sabrina* co-star and one-time lover William Holden.

The somewhat absurd plot – Hepburn plays a secretary who helps a playboy screenwriter test out increasingly desperate scenarios for his screenplay, as his deadline approaches – gave Hepburn and Givenchy a chance to indulge themselves.

As Gabrielle Simpson, Hepburn's outfits ranged from simple shift-style day dresses in pastel colours – befitting the secretary's bubbly character – and a pale lime green bouclé travelling suit, to a full-on medieval costume made from cream silk brocade. And as the face of Givenchy's debut fragrance, *L'Interdit*, Audrey Hepburn made a point of wearing the scent during the film. In

BELOW As part of his remit to design all of Audrey Hepburn's costumes for her films, Givenchy was sometimes called upon to create something a little out of his ordinary classic style. This cream silk brocade medieval "costume" was created by the designer for a scripted scene.

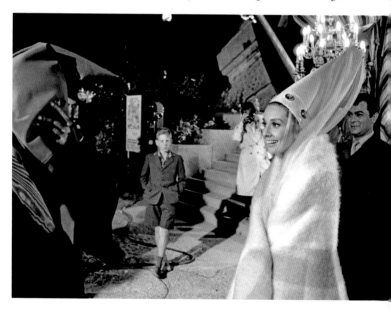

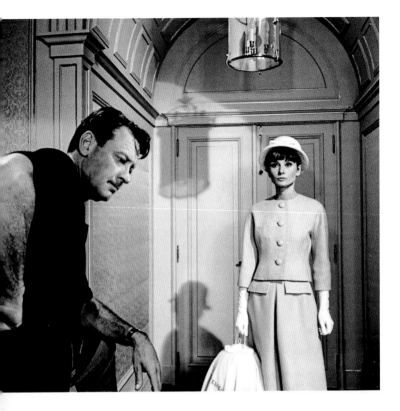

ABOVE This classic
pale lime bouclé
wool travelling suit
accessorized by long
white gloves and a
straw hat is typical
of the elegant outfits
Givenchy created for
Audrey Hepburn to
wear in the film *Paris
When It Sizzles*.

the film's credits, Givenchy is credited for the perfume alongside his costume design.

The studio had some reservations about how successful the film would be, leading them to hold it for release until 1964. This meant that *Charade*, which started shooting just two days after *Paris When It Sizzles* wrapped, was released first. As feared, *Paris When It Sizzles* wasn't a great success, but Hepburn's performance was well received and, as always when Givenchy was in charge, her costumes were deemed impeccable.

CHARADE

Released in 1963, *Charade*, a murder mystery sprinkled with a heavy dose of comedy, sees Hepburn acting the part of Regina Lampert, the wife of the murder victim, alongside love interest Cary Grant. *Charade* was also set in Paris and is widely regarded as one of Hepburn's best performances. The film is resplendent with Givenchy's elegant suits and dresses, as well as standout costumes for particular dramatic scenarios, including figure-hugging ski-wear.

For *Charade*, Givenchy included bold colours such as red and yellow alongside his classic palette of neutral hues. The colours gave some clues about Regina Lampert's character, revealing the designer's gift for costume design. The immaculately

BELOW Givenchy often used animal prints in his couture collections and this stylish leopard-print pillbox hat, one of a number he designed for Hepburn to wear in *Charade*, is typical of the designer.

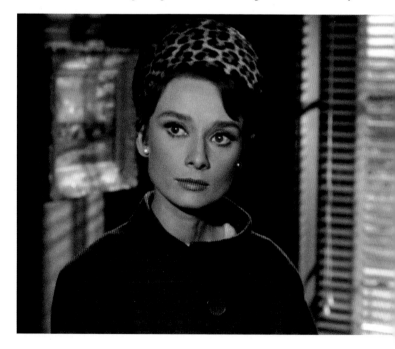

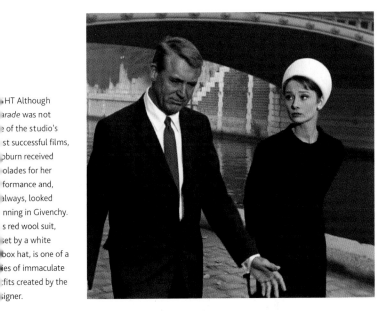

cut coats with their funnel collars and three-quarter length sleeves, worn with pillbox hats, illustrate his even greater talent as a couturier.

Hepburn often said that Givenchy's costumes allowed her to fully get into character. They also helped the actress, who admitted she sometimes suffered from insecurities, feel her best. Of the costumes in *Charade* she said:

"Wearing Givenchy's lovely simple clothes, wearing a jazzy little red coat and whatever little hat was then the fashion – I felt super."

LEFT Bold colours, such as the vibrant yellow of this funnel neck coat, were used by Givenchy in *Charade* to suit the feisty character played by Hepburn in this comic murder mystery.

OPPOSITE The most simple of Givenchy dresses, such as this ivory wool shift, became the height of elegance when worn by Audrey Hepburn

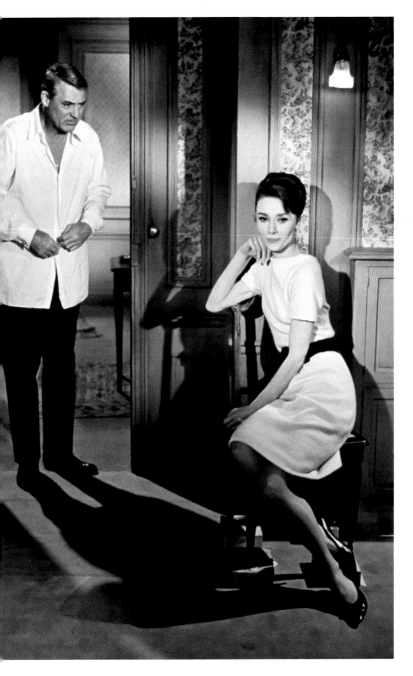

HOW TO STEAL A MILLION

The 1966 film *How to Steal a Million* was the last major collaboration between the actress and designer and saw Givenchy's designs for Hepburn develop a more 1960s feel. In part, this was because of the leading lady's dramatic new hairstyle, a fashionable elfin crop. The short style suited a series of simple, tailored outfits in bright pink or yellow, always paired with a matching hat. The clean lines of Givenchy's fitted suits, worn with Hepburn's preferred low heels, were offset by a coat in the new voluminous "sack" silhouette.

Monochrome looks are also a big part of Hepburn's wardrobe in this film, including a black dress trimmed with a white collar and the memorable cream skirt suit, paired with a white helmet hat and Oliver Williams white sunglasses, in which she drives an open-top red car.

In *How to Steal A Million* Hepburn plays the role of Nicole, an art forger's daughter who plans to steal a Cellini statue with her partner, Simon (Peter O'Toole). Nicole is always immaculately dressed, except in the scene when the pair commit the crime. Then she disguises herself as a cleaner, leading Simon to deliver the tongue-in-cheek line:

"Well, it gives Givenchy a night off!"

Givenchy contributed clothes to two further films for Audrey Hepburn, *Bloodline* in 1979 and the made-for-TV film *Love Amongst Thieves* in 1987, and continued to design for the actress off-screen.

OPPOSITE This iconic image from *How to Steal a Millic* sees Givenchy dress Audrey Hepburn in a cream skirt suit, paired with a white helmet hat and Oliver Williams whi sunglasses.

LEFT The last major film for which Givenchy designed Hepburn's wardrobe was *How to Steal A Million* in 1966 and included outfits such as this black Chantilly lace cocktail dress. The matching eye-mask is perfect for the character's planned heist.

OFF-SCREEN

"Givenchy's creations always gave me a sense of security and confidence and my work went more easily in the knowledge that I looked absolutely right. I felt the same at my private appearances. Givenchy's outfits gave me 'protection' against strange situations and people. I felt so good in them."

A naturally private person, Audrey Hepburn used Givenchy's clothes as a type of "armour" to give her confidence during public appearances. Self-conscious about her skinniness, a result of being malnourished as a young teen during World War II, she also appreciated how his designs flattered her physique. Hepburn wore Givenchy to the majority of her film premieres, including *Breakfast at Tiffany's*, and for Academy Awards ceremonies. He also designed her wedding dress for her second marriage to Andrea Dotti in 1969. Made from pink jersey, with an empire waistline, it is fashionably short and very much of its period.

As a popular style icon Audrey Hepburn was often featured in fashion magazines and *Vogue*, in particular, highlighted her relationship with Givenchy. The actress was so loyal to the designer that she happily agreed to editorial shoots in which she wore Givenchy's newest fashions including, in 1963, an unprecedented 10-page spread, shot by Bert Stern. And in 1971, to promote Givenchy's Nouvelle Boutique collection, designed for the countryside, Hepburn posed against a pastoral setting, approaching the shoot very much in the same way she might perform a cinematic role.

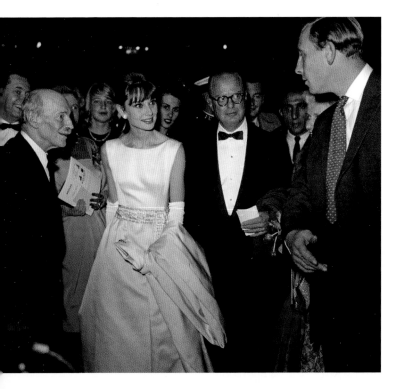

ABOVE Givenchy
made many of
Audrey Hepburn's
gowns for special
occasions. She
wore this stunning
sleeveless, jewelled
gown for the
UK premiere of
Breakfast at Tiffany's.

These images of Audrey in Givenchy were shot by the most prestigious photographers of the day, including Irving Penn, Richard Avedon and Cecil Beaton. American *Vogue* commented on the unique synthesis between the designer and muse: "What fires his imagination races hers. The message he cuts into cloth she beams into the world with the special wit and stylishness of a great star."

The mutual inspiration that Givenchy and Audrey Hepburn enjoyed lasted until Hepburn's death in 1993. The depth of feeling that the designer held for his lifelong friend is summed up in his own words: "In every collection a part of my heart, my pencil, my design goes to Audrey."

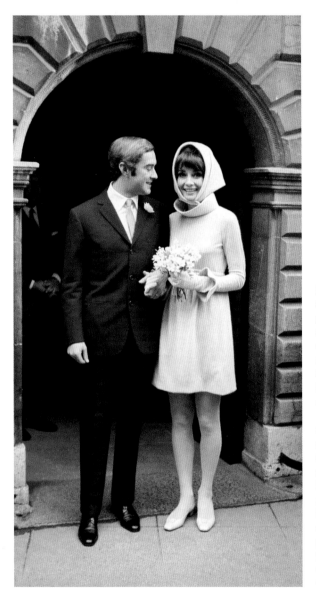

LEFT Givenchy designed this simple yet elegant wedding outfit of a pale pink dress with funnel collar and matching headscarf for Audrey Hepburn's marriage t Andrea Dotti in 1969

OPPOSITE Hepburn continued to wear Givenchy's beautiful gowns throughout her life. The actress is pictured here in 1991 looking as stunning a ever in a black velvet gown with bolero jacket featuring the designer's trademark voluminous sleeves.

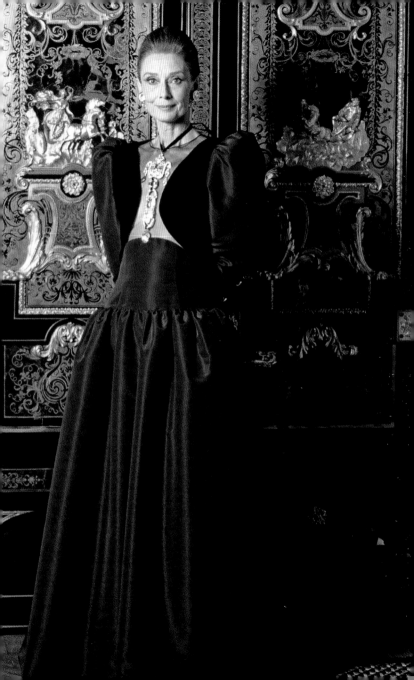

EXPANDING
THE HOUSE

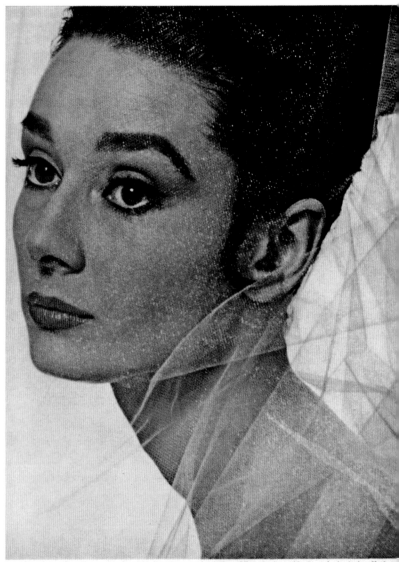

Once she was the only woman in the world allowed to wear this perfume. L'Interdit. Created by Givenchy for Audrey Hepburn

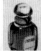

MOVING BEYOND HAUTE COUTURE

Balenciaga encouraged Givenchy to expand and diversify his brand, and this approach contributed greatly to the label's success.

PERFUME

The first step was to found Parfums Givenchy, which was originally housed alongside Balenciaga's own perfumes, until a perfume production plant was opened in Beauvais.

Givenchy's debut fragrance, *L'Interdit*, was reputedly created for Audrey Hepburn when she could not find a scent she liked. The "nose" behind *L'Interdit* was Francis Fabron and true to its name, which translates as The Forbidden, only Hepburn was allowed to wear it for a full year before it went on general sale.

The distinctive perfume, a floral aldehyde in the manner of classics like *Chanel Nº 5* and Lanvin's *Arpège*, was described by *Vogue* as "exotic, mysterious, heady." Givenchy asked Hepburn to appear in the advertising for the fragrance and in doing so she became the first celebrity "face" to endorse a product in a way that is commonplace today. Hepburn even wore the

OPPOSITE Givenchy created his debut perfume *L'Interdit* for his muse Audrey Hepburn who became the first celebrity "face" of a scent. As part of the arrangement to promote the perfume, Hepburn was also the only woman allowed to wear it for its first year.

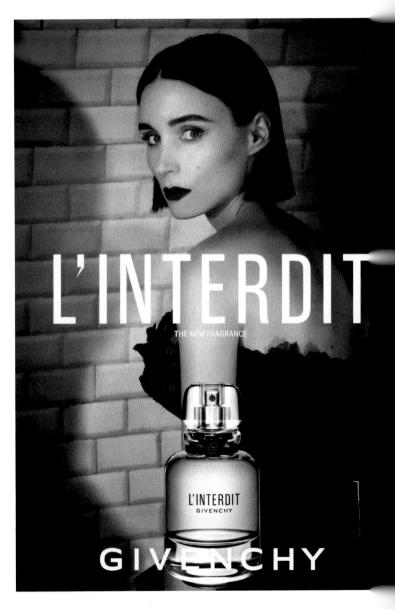

scent during the filming of *Paris When It Sizzles* and Givenchy received a screen credit for it.

Following the success of *L'Interdit*, the next two years saw the launch of *Monsieur Givenchy* and *l'Eau de Vetiver*. Then there was an interval of a decade until the next fragrance, *Givenchy III*, appeared. Its advertising campaign cast wearers as seductive sirens: "Who knows why one is reminded of a particular woman and not another one? *Givenchy III* gives memories to men."

But the real impetus behind Givenchy wanting to create perfumes was to give women another reason to feel confident and comfortable in their appearance. The designer once said that fragrance was the "finishing touch", to a woman's outfit and like many of his contemporaries, his ultimate goal was to cater to a woman's whole appearance. This aspiration eventually culminated in the founding of Givenchy cosmetics and skincare in 1989.

Over the past seven decades the house of Givenchy has created a suite of enchanting fragrances, including *Véry Irrésistible*, *Dahlia Noir* and the L'Atelier de Givenchy collection, inspired by dresses from the Givenchy couture archives. As with Givenchy's iconic little black dresses, his classic scents have been reinvented over the years. *L'Interdit* was last reformulated in 2018, packaged in a bottle that paid homage to its original shape.

MENSWEAR

Givenchy was devoted to womenswear, both haute couture and ready-to-wear, and alongside Balenciaga, he redefined the style of a generation of women. The designer always considered menswear to be less important than womenswear but, keen to expand his business where possible, he launched Givenchy Gentleman in 1969.

OSITE A more
temporary actress
ecome the face of
fragrance *L'Interdit*,
one who shares
Irey Hepburn's
nine beauty, is
ney Mara.

Produced under licence, like Givenchy's fragrance and accessories lines, the menswear label offered a somewhat unadventurous but carefully curated selection of elegantly tailored clothes that epitomized everything Givenchy stood for. A well dressed man was an important accessory to the sophisticated woman. The line's advertising campaigns during the 1980s played on this idea, a typical image featuring a man in a perfectly cut tuxedo gazing adoringly as the iconic Givenchy woman descended a grand staircase.

In an advertisement which appeared on Italian television, a husband is about to walk in on his wife with another man, when he spots her lover's Givenchy tie. "Thanks, honey," he says. "What a nice surprise." As Eamon Levesque summed it up for *Grailed* magazine in 2018: "The message to the reader is simple: the women who wear Givenchy are amazing. Maybe if you wear some, you'll get a shot at them."

Unlike Givenchy's womenswear, which was often linked to some of the most notable style icons of the day, his menswear flew under the radar. For example, Jackie Kennedy's immaculate and much commented-on Givenchy outfit for the funeral of her husband John F Kennedy immediately entered the annals of style history. The fact that her brothers-in-law Bobby and Ted Kennedy, photographed at her side, were also wearing custom-made suits by Givenchy is a little known fact.

For three decades, Givenchy menswear continued a modest production but was never hugely successful and remained far below the stellar heights achieved by Givenchy womenswear. Not until 2004, almost a decade after Givenchy himself had retired and the designers John Galliano, Alexander McQueen and Julien Macdonald had come and gone, did the brand attempt to resurrect its menswear by appointing Ozwald Boateng as its dedicated designer.

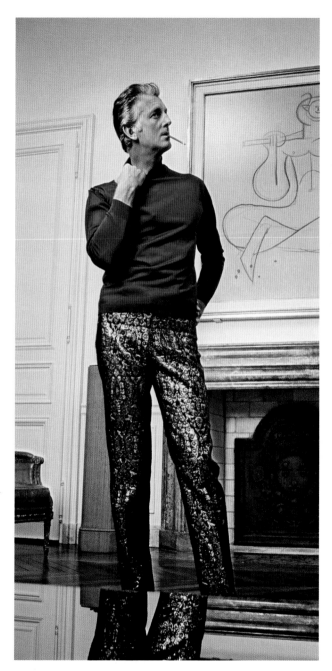

RIGHT The early years of Givenchy menswear were somewhat hit and miss, lacking the timeless elegance of his menswear. Here Givenchy himself poses in sequinned trousers and a tight blue polo-neck.

The successful British tailor should have been the perfect choice. He had redefined contemporary menswear, drawing a new and youthful clientele to the traditional enclave of Savile Row. Most importantly he ostensibly embodied the same ethos as Givenchy himself, that of honouring traditional lines and techniques but with a modern twist. As Boateng explained in an interview with *Icon Mann*, his brief at the fashion house was to "reinvent the French gentleman," which, he claimed, "I succeeded in doing." He continued:

Commercially, I was able to restructure their collection and make it viable for a current consumer which added a lot to the brand's bottom line. During my tenure, just by adjusting how the collections were designed and produced, we managed to save 20 to 25 per cent."

Unfortunately, the avant-garde styling of the campaigns – including a Japanese manga-style short film, directed by Boateng, to launch his debut collection for Givenchy – were poorly received and not at all in keeping with the traditional ethos of the couture house. Regardless of whether things improved commercially, the pastel tones and metallic fabrics used by Boateng didn't match what the brand envisaged for their menswear collections. Nevertheless, whether you like or loathe Boateng's designs for Givenchy, they did have a lasting influence on men's fashion, as Eamon Levesque pointed out: "It's extremely hard to deny that this aesthetic lived on in menswear for several years. The collections are exemplary of mainstream tailoring in the early to mid-2000s."

OPPOSITE Celebrated British tailor Ozwald Boateng took over Givenchy menswear 2004. However, his collections were poorly received and he left 2007.

Echoing the words he had expressed at the end of Alexander McQueen's unsuccessful tenure, Givenchy himself finally felt obliged to weigh in on the debate, stating in an interview with *WWD*:

"I suffer. What is happening doesn't make me happy. After all, one is proud of one's name."

Ozwald Boateng left the house in 2007. In 2009, Riccardo Tisci, a relative newcomer to the industry who had been designing womenswear at Givenchy since 2005, took over menswear, becoming the first creative director to have full control over both womenswear and menswear for the label. Under Tisci's stewardship, Givenchy's menswear collections finally started to live up to the house's reputation.

Tisci's menswear vision was very different to that of his contemporaries. He drew on his Italian Catholic heritage and love of gothic atmosphere to create, as Tim Blanks put it for *Vogue*: "The boy-scout-gone-bad look."

But the designer managed to tap in to the heritage of Givenchy tailoring to present expertly crafted suits, even if they did appear alongside athleisure and featured accents of bright fuchsia.

Giving Givenchy a streetwear edge, Tisci's approach bore fruit when renowned rappers Jay-Z and Kanye West commissioned the designer to create the outfits for their 2011 *Watch the Throne* tour – and to collaborate on the album graphics and tour merchandise. Finally, Givenchy menswear had developed a successful identity, which has continued to go from strength to strength.

OPPOSITE Jay-Z pictured on stage wearing one of Riccardo Tisci's designs. The publicity around the *Watch The Throne* tour transformed the reputation of Givenchy menswear.

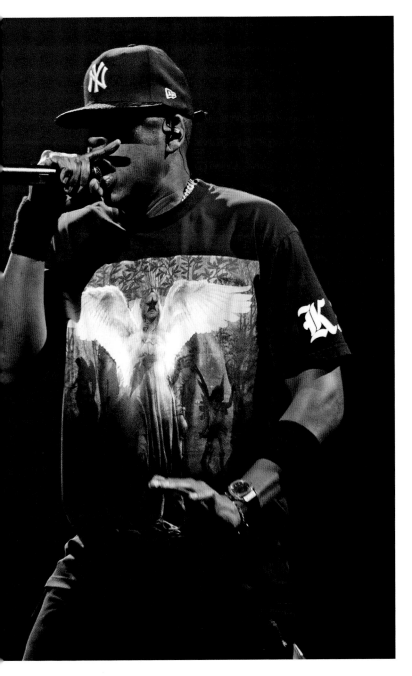

ACCESSORIES

During the 1970s, following the launch of its menswear lines, Givenchy continued to seek out more licensing partnerships. The fashion house allowed independent producers to use its name and logo on new products licensed to the brand. Givenchy was one of the first fashion designers to employ this business model, licensing up to 180 different operations, and it has since become commonplace among luxury fashion brands.

Over the next two decades, the range of accessories that appeared under the umbrella of the label included eyewear, ties, shoes, sportswear, jewellery, watches and even homeware, making the Givenchy name synonymous with a highly sophisticated French lifestyle. In 1979, the house of Givenchy even lent its name to the luxurious interior of a Lincoln Continental.

While immaculate sculptural hats, often venturing into the realms of theatrical fantasy, had long been designed by Givenchy himself as part of his couture outfits, and shoes and bags were always contrived to match, status bags were not a big part of the fashion house's remit until after his retirement. Designers John Galliano and Alexander McQueen ventured into designing bags for their catwalk collections at Givenchy, but the label did not become a notable name in the "It" bag market until the arrival of Riccardo Tisci in 2005. Tisci, a skilled and inventive designer of both shoes and bags, created popular statement pieces including the Horizon, Pandora and Antigona bags.

OPPOSITE
From the 1970s onwards Givenchy issued licenses for accessories to be manufactured und the fashion house' name. Eyewear proved a particular success.

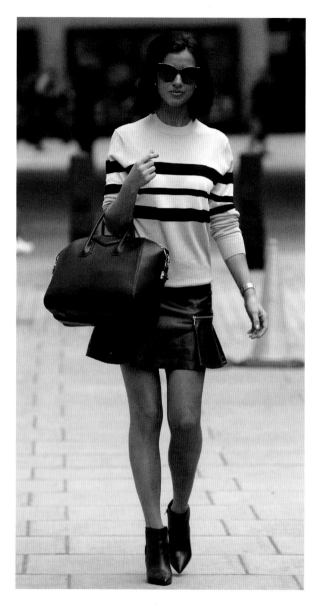

LEFT Givenchy entered the "It" bag market with Riccardo Tisci's designs, including the Antigona and, pictured here on the arm of a Milan fashion-goer, the Pandora.

OPPOSITE Taking Givenchy footwear thoroughly into the modern age are a pair of bright yellow moulded boots from the womenswear Spring/Summer 202. collection.

LVMH

In the fast-changing fashion business of the 1970s and 1980s, many of Givenchy's contemporaries were being lured into the folds of one of the big luxury goods conglomerates. In 1988 Givenchy finally acquiesced, selling Givenchy Couture to LVMH (Moët Hennessy Louis Vuitton) for a reported $45 million, two years after the luxury goods conglomerate had acquired his subsidiary perfume business.

In 1995 Givenchy retired after four decades at the pinnacle of haute couture. His public accolades included the Chevalier de la Légion d'Honneur in 1983 and a lifetime achievement award from the Council of Fashion Designers of America in 1995. He had taken fashion to new heights of elegance, never wavering from a central design tenet that he once expressed with the words: "I love purity and refinement."

BELOW After selling Givenchy to LVMH in 1988, Hubert de Givenchy devoted himself to his passio for art and interiors, officially retiring in 1995. Here is a recreation of a room part of a large sale of the designer's antiqu from his homes in th Hôtel d'Orrouer and the Manoir du Jonch held by Christie's in Autumn 1993.

Givenchy subsequently devoted himself to his private passions as an art collector and interior designer. He sold many of his finest pieces at Christie's in the autumn of 1993 to release funds for more acquisitions. Givenchy frequently redecorated the seventeenth century Manoir du Jonchet near Versailles, which he had bought in 1976. His love of gardens, a passion he shared with Audrey Hepburn, was legendary. The landscaped grounds of his property were as perfectly executed as his couture clothes. He also owned a property at Cap Ferrat on the Cote d'Azur and enjoyed luxury boats and cars. Hubert de Givenchy died at the age of 91 on March 10, 2018.

THE RICH
AND FAMOUS

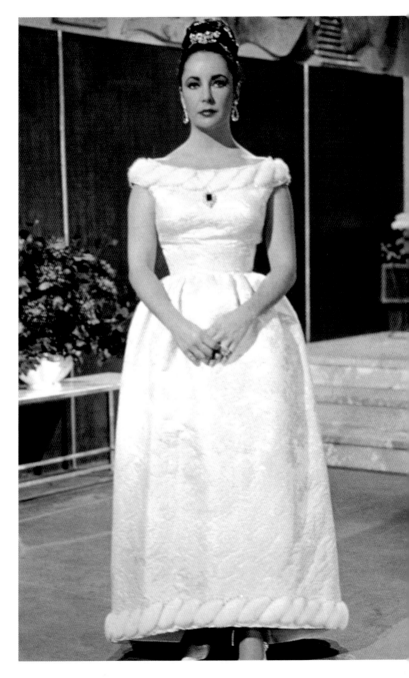

CELEBRITY CLIENTELE

"To be a couture designer is not only to create dresses but to adapt your line to your private customers. It is why couture is expensive. You are like a doctor."
– Hubert de Givenchy

Givenchy's skill as a couturier – along with his charm and charisma – combined to make him one of society's most sought-after designers. As well as being linked with Audrey Hepburn, Givenchy also designed outfits for a host of other famous and stylish women. As he recalled in *Vanity Fair* magazine in 2014: "I dressed so many other stars. Jennifer Jones, Lauren Bacall, Marlene Dietrich, Elizabeth Taylor – we had such problems with her, with the timing of her fittings. Not like Audrey, she was always late."

The great actresses who wore Givenchy's designs included Greta Garbo, Ingrid Bergman and Sophia Loren, and style icon Jackie Kennedy was also a longtime client. An early fan of the French designer, Kennedy attended secret fittings with Givenchy in 1961, during her first state visit to Paris with her newly elected husband, John F Kennedy. The youngest First

OPPOSITE Elizabeth Taylor was one of Givenchy's clients although the designer complained about her always being late for fittings. She is pictured here in 1963 in an ermine-trimmed brocade silk gown.

Lady in nearly eighty years – she was just thirty-two years old – was greatly admired when she appeared at a reception at the Palace of Versailles dressed in an ivory silk Givenchy gown, embroidered with silk ribbon and adorned with seed pearls.

Kennedy, both during her years as First Lady and later when married to Aristotle Onassis, frequently chose to wear Givenchy, but her most memorable outfit by the designer would be the black suit she wore to her husband's funeral. The eyes of the world were upon her: there could be no more dignified picture of grief than the widow wearing a simple black wool suit, a neat jacket and a pillbox hat with a veil.

Arrangements for the funeral began barely hours after Jackie Kennedy returned to the White House following the fatal shooting of the president, so it is unlikely that Givenchy would have been able to create a suit specifically for the occasion, even though he was said to have kept the measurements of all the Kennedy clan on file. It is more likely that the outfit was one she already possessed and in fact, photographs from 1960 show her wearing what is likely to be the same jacket. Nevertheless, Givenchy's name has become permanently linked to Kennedy's, and to her style legacy.

Givenchy has dressed a roll call of glamorous names over the years. Hollywood star turned Princess of Monaco Grace Kelly turned to Givenchy for state occasions, choosing a forest green tailored suit with a striking white feather-covered turban-style hat to visit the Kennedys at the White House in 1961.

The Duchess of Windsor, Wallis Simpson, who had a lifelong reputation for sophisticated style, was another fan, often attending Givenchy's salon to acquire couture outfits. The designer recalled for *Vogue* how her husband the Duke once said to him: "'Givenchy, you know, I really like what you do for the Duchess.' But just as I replied, 'Thank you, it's very

OPPOSITE One of Givenchy's most famous outfits was worn by Jackie Kennedy to the funeral of her husband John F Kennedy in 1963. The simple black wool suit and neat jacket was matched with a pillbox hat and veil.

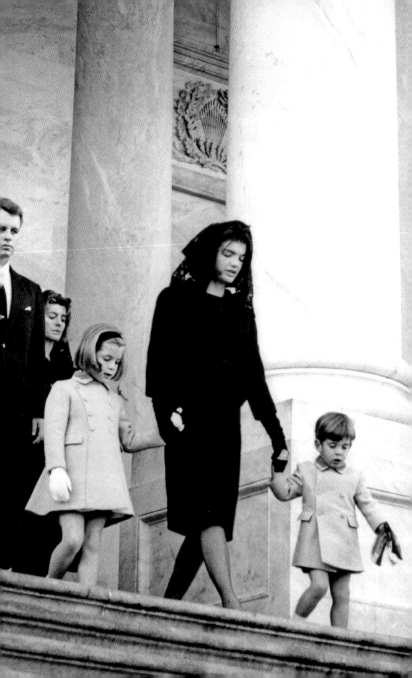

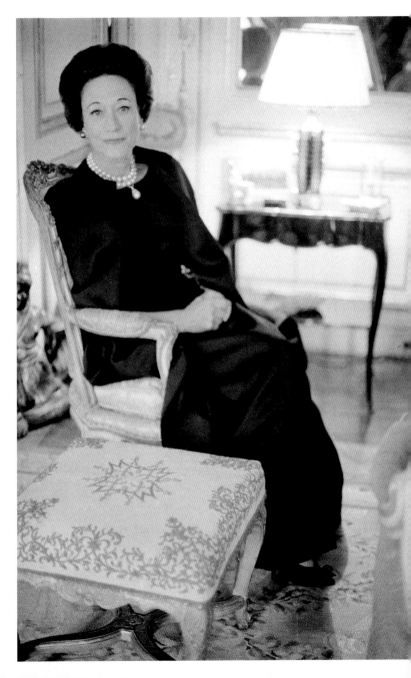

kind of you to tell me that, it's very encouraging,' he suddenly asked me, 'Why is the price so high?'"

On hearing this, the Duchess interrupted: "Do you think the price is so high for all the joy and pleasure I give you with all the lovely dresses Hubert has designed for me?"

Like Jackie Kennedy, the Duchess of Windsor also turned to the understated elegance of Givenchy for her mourning outfit at her husband's funeral. The couturier stayed up all night to create a simple black dress and double-breasted coat. The outfit was finished with a dramatic veil which, as the *Daily Telegraph* put it "was a contrast to the more muted hats worn by the Queen and other members of the royal family." It was a somewhat barbed comment as though widely regarded as a style icon, Wallis Simpson was looked down on as vulgar for her obsession with Paris fashion by the British establishment.

It has been said that the exquisitely tailored clothes designed by Givenchy himself belong to a different era, one of little relevance to today's customer. In the 2012 documentary on the trailblazing *Vogue* editor, *Diana Vreeland: The Eye Has to Travel*, the arbiter of style is seen complaining to Givenchy, as she examines some of his most fabulous dresses, that modern women do not appreciate the fabric and workmanship of couture clothes any more:

"Do they realize what it would be like to be in a dress like this? You'd feel so comfortable, so luxurious."

But in fact, since Givenchy's retirement, the fashion house's haute couture line, under the direction of more contemporary designers-in-chief, has appealed to a new generation of stylish celebrities. When Kim Kardashian married Kanye West in Florence in 2014,

Riccardo Tisci designed her figure-hugging lace gown, which featured full-length sleeves and dramatic cut-out panels.

Another wedding dress by the House of Givenchy, this time the creation of British designer Clare Waight Keller, was worn by Meghan Markle for her marriage to Prince Harry on May 19, 2018. The full-length ivory silk gown, which cost £200,000, was signature Givenchy in style, featuring the iconic bateau neckline and three-quarter length sleeves. According to a statement put out by Kensington Palace at the time, Givenchy qualities of simple elegance and immaculate construction were the perfect recipe for a modern royal wedding dress.

"True to the heritage of the house, the pure lines of the dress are achieved using six meticulously placed seams. The focus of the dress is the graphic open bateau neckline that gracefully frames the shoulders and emphasizes the slender sculpted waist. The lines of the dress extend towards the back where the train flows in soft round folds cushioned by an underskirt in triple silk organza. The slim three-quarter sleeves add a note of refined modernity."

As Givenchy fashions have moved in the direction of street style, a new raft of celebrities has embraced the brand. A turning point came when Riccardo Tisci was commissioned to design the artwork and stage attire for Kanye West and Jay-Z's 2011 *Watch the Throne* tour, which hit the headlines when West wore a Givenchy pleated leather skirt by Tisci.

Since street-style legend Matthew Williams took the helm at the fashion house in 2020, a new era of celebrity endorsement has dawned at Givenchy. Sneak previews of Williams' debut campaign appeared ahead of his catwalk show as selfies on the Instagram feeds of a youthful generation of trendsetters, including Kendall Jenner, Bella Hadid, Skepta, Playboi Carti and Travis Scott.

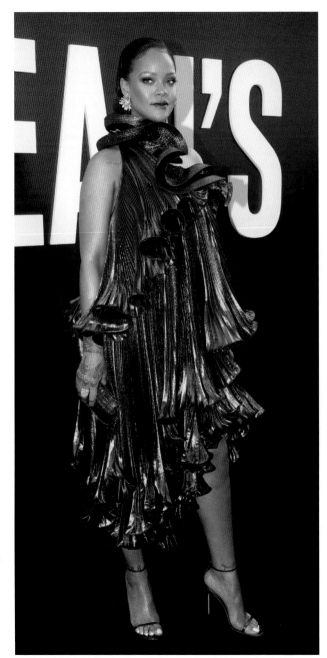

RIGHT Rihanna chose
a stunning pleated
Givenchy dress in
shining metallic purple
for the premiere of
Ocean's 8 in New York
2018.

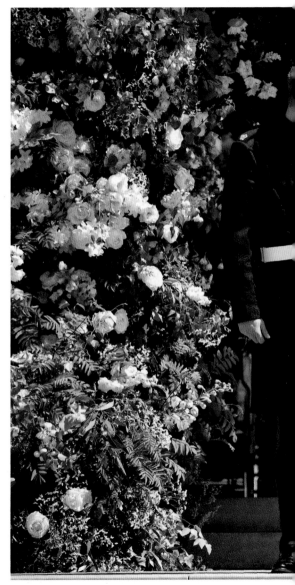

RIGHT A more recent American duchess to choose a Givenchy gown is Meghan Markle who chose then-designer-in-chief Clare Waight Keller to design her wedding dress for her marriage to Prince Harry. The full-length ivory silk gown, with a triple-silk organza underskirt, cost £200,000 and bore classic Givenchy signatures including the iconic boat neckline and three-quarter length sleeves.

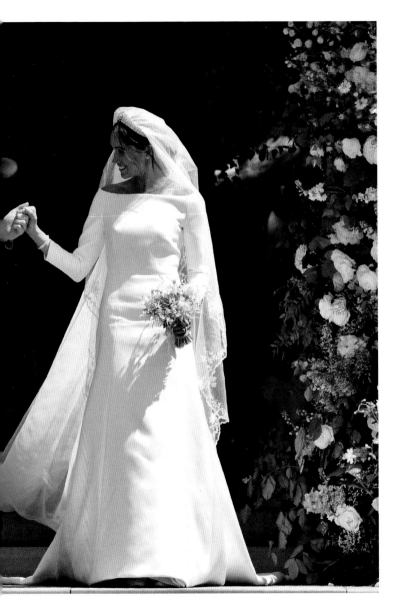

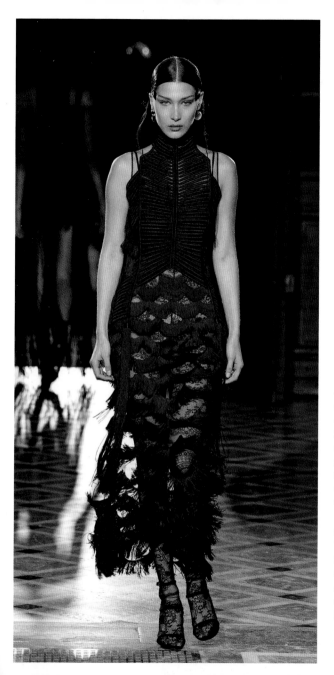

LEFT Bella Hadid is a big fan of Givenchy couture both on and off the catwalk. She is pictured here modelling a high-necked fringed black lace column dress for the label's Autumn/Winter 2017 show.

OPPOSITE Rapper Travis Scott pictured intently watching the Givenchy Menswear Autumn/Winter 2017 show during Paris Fashion Week.

A NEW GENERATION

BEYOND GIVENCHY

Hubert de Givenchy retired in 1995, aged 68, and at his final couture show the emotion was palpable.

In a touching gesture Givenchy invited his atelier workers to bow alongside him as he walked out onto the catwalk for the final time. Decades of achievement as one of the fashion world's most esteemed couturiers were acknowledged with a standing ovation from the audience, which included several of his fellow designers. Those honouring Givenchy's accomplishments and legacy included Yves Saint Laurent, Valentino, Christian Lacroix and Oscar de la Renta. Since his departure, a series of fashion designers, high profile and lesser-known, have taken the reigns at the fashion house to varying degrees of success.

OPPOSITE Hubert de Givenchy is applauded by models as he appears on the catwalk after his final show, for Autumn/Winter 1995.

JOHN GALLIANO

The day after Givenchy's retirement his replacement was announced as John Galliano. At the time, Galliano would be the first British designer to control a Parisian couture house since 1858, when Charles Worth established his own business and revolutionized the world of high fashion. Despite his reputation as an "enfant terrible" of the fashion world, great things were expected of Galliano, who, it was hoped, would breathe fresh life into the traditional label.

Although Galliano's appointment was ultimately down to LVMH chairman Bernard Arnault, he had been heavily tipped for the role by fashion insiders including American *Vogue* editor Anna Wintour and André Leon Talley, then at *Vanity Fair*. Speaking to the *New York Times*, Talley defended the choice.

Speculation was rife before Galliano's first Givenchy couture show, for Spring/Summer 1996. Would he, as rumoured, resurrect the Audrey Hepburn years of gamine elegance at Givenchy? The answer was a resounding no. Instead, Galliano presented a romantic, fantastical collection. It began with a throwback to the voluptuous ballgowns of his own French Revolution-inspired graduate collection from 1984, *Les Incroyables*, and continued on a whirlwind tour of twentieth-century fashion history. As *Vogue* put it in their 2020 retrospective: "Tuxedo clad Helmut Newton heroines followed, then flappers, styles from the 1940s, and 1950s looks. Conjuring Roman holiday were the finale dresses, made of red sari silk woven through with gold with a cartoonish *Cleopatra*/Cinecittà vibe."

There were subtle touches of classic Givenchy in certain fripperies, such as the designer's beloved bows and Carla Bruni's appearance in a black column dress that echoed the enduring look from *Breakfast at Tiffany's*. But in essence, Galliano's debut was a definitive statement that he was going to do things his own way.

Despite a somewhat mixed initial reception, the overall consensus on the collection was positive, summed up by Tamsin Blanchard in the *Independent* who wrote: "The appointment will inject new life into both Givenchy and haute couture itself."

This shaking up of the French haute couture scene was a deliberate move, cleverly orchestrated by LVMH chief Bernard Arnault. Dubbed the "Pope of Fashion" by *Women's Wear Daily*, Arnault had by this time acquired several historically important fashion labels. Louis Vuitton and Christian Dior had been the jewels in the crown since Arnault's original investment in 1987, but subsequent additions included Christian Lacroix, Loewe, Céline and, of course, Givenchy. This gave the luxury goods conglomerate extraordinary power in redefining the fashion landscape.

Galliano played an important role in that sea change, but he did not stay long at Givenchy. Just a year later, Arnault made the surprise decision to move him to Christian Dior, replacing him at Givenchy with his fellow "bad boy" British designer, Alexander McQueen.

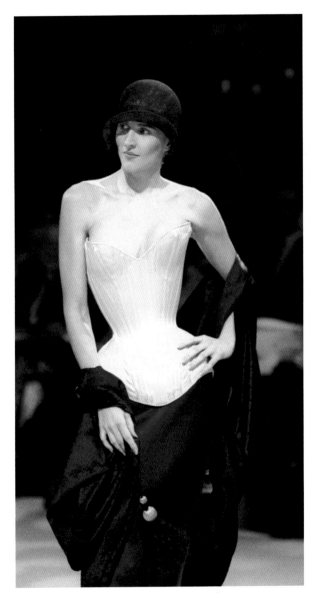

LEFT This shot of a model in a pale pink corseted bust with black satin skirt, draped shaw and cloche hat fror Galliano's Spring/ Summer 1996 sho for Givenchy's couture collection made it clear that he would retain hi penchant for styliz form-fitting desigr

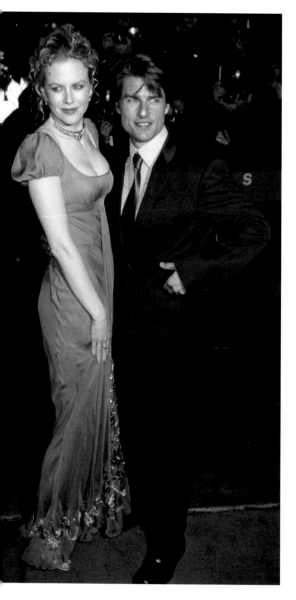

LEFT Nicole Kidman
wearing a stunning
John Galliano for
Givenchy outfit to
the premiere of *The
Portrait of a Lady*
in 1996. The green
chiffon gown has a
period-feel scooped
neckline and a
skirt embellished
with red and white
embroidered roses.

ALEXANDER MCQUEEN

Like Galliano, McQueen was a theatrical and extravagant designer who could not have been more different in style to the understated Hubert de Givenchy. Nevertheless, both Brits shared the legendary designer's technical brilliance when it came to haute couture fashion.

Despite unwisely announcing on his arrival in Paris that Givenchy himself was "irrelevant", the 27-year-old McQueen threw himself into his first couture show for Spring/Summer 1997. Inspired by ancient Greece, it was titled Search for the Golden Fleece and its palette of gold and white was inspired by the Givenchy motif. Full of bizarre naturalistic elements, including sheep's-horn headpieces and a model wearing gigantic wings, perched on the first-floor balcony of the École des Beaux-Arts, the show was not received well, with Amy M Spindler in the *New York Times* writing: "It seemed too strange for Givenchy couture and not creative enough for his own name."

McQueen himself admitted to American *Vogue* in October 1997: "I know it was crap."

Nevertheless, the cockney designer refused to be quashed, producing shows simultaneously for the Alexander McQueen label and the House of Givenchy. His critical success under his own name went a long way in shoring up his credibility at Givenchy, where his next ready-to-wear collection for Autumn/Winter 1997, entitled Lady Leopard, saw models clad in animal skins prowl through a former slaughterhouse. McQueen explained that the show took inspiration from the underground world of drag queens and low-budget sexploitation films. McQueen's approach to portraying women was very different to Givenchy's. McQueen's work has been criticized as misogynistic, while Givenchy put elegant, feminine women on a pedestal and was committed to making them look and

OPPOSITE
Alexander McQueen the second "bad boy" of British fashion to land at Givenchy, took over from John Galliano in 1996. This revealing shot from his Spring/Summer 1997 haute couture show for Givenchy demonstrates that was unafraid to push boundaries at the traditional fashion house.

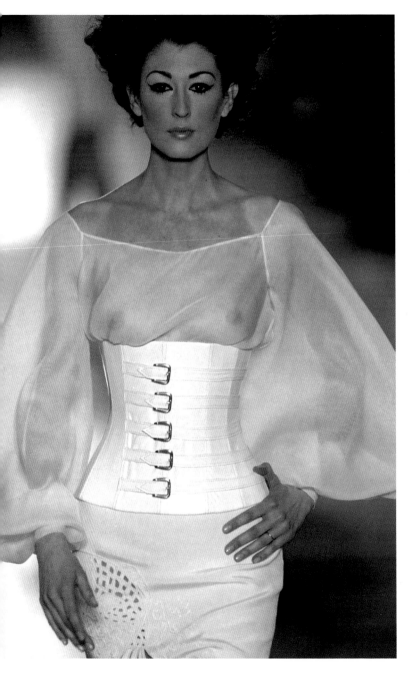

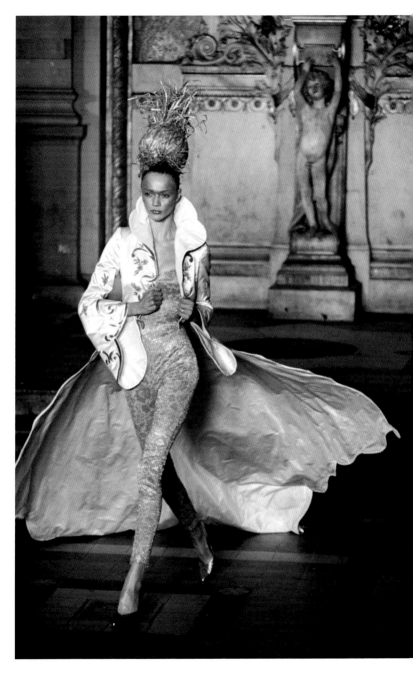

feel good. Defending himself against his critics, particularly in the light of his early collections under his own name, in which women appear victimized and sometimes even sexually abused, McQueen told the writer Dana Thomas: "Those women took their men, chewed them up and spit them out. Some people say I'm a misogynist. But it's not true. Opposite. I'm trying to promote women as the leaders. I saw how hard it was for my mum to take care of us, and I try to promote the respect and strength of women."

Lady Leopard was more positively received, with Iain R Webb in *The Times* writing: "This collection proved that the young punk from East London is now ready to play with the big boys."

McQueen remained unable to resist controversy and his second haute couture show, entitled Eclect Dissect, was extremely contentious. The show, devised in collaboration with his art director Simon Costin, recalled the story of an 1890s surgeon who killed women around the world and then put them back together piecemeal. Myriad cultural references were expertly sewn together, highlighting McQueen's brilliance as a tailor and couturier. McQueen's favourite bird motifs included a model wearing a hat in which a live bird was trapped, and a model carrying a falcon.

Unfortunately, despite his obvious brilliance, McQueen's designs never quite landed at Givenchy. His work was outright condemned by Hubert de Givenchy, who told the *Daily Telegraph*: "I glance at the fashion pages to see what's happening at Maison Givenchy. Total disaster."

Over the next couple of years McQueen experimented with showing clothes entirely on plastic mannequins rather than models, attempted commercial success with a series of unexciting designs and eventually created controversy by selling a controlling

OPPOSITE Jodie Kidd modelling in Alexander McQueen's debut show for Givenchy Spring/Summer 97. She wears a gold brocade bustier suit topped by a gold-embroidered, Marie Antoinette style white silk coat with scalloped hemline, the outfit finished by a flamboyant headpiece. The theme was Ancient Greece, its palette of gold and white inspired the Givenchy motif.

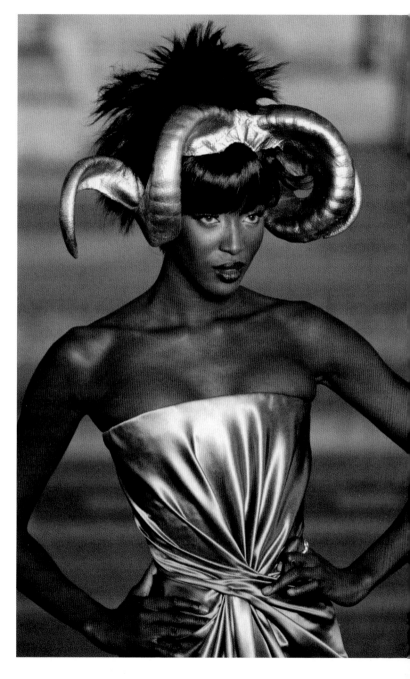

ABOVE The atmosphere
of Ancient Greece was
enhanced by models
perched on the first floor
balcony of the École
des Beaux-Arts, wearing
giant wings. Despite the
trademark McQueen
theatrics, the show was
poorly received.

OPPOSITE Naomi Campbell
epitomizes the Grecian
theme in a glossy gold
strapless ruched gown with
dramatic moulded sheep
horn headpiece.

stake in his own Alexander McQueen label to LVMH's rival
Gucci group, leaving his position at Givenchy untenable.
His final two collections were shown behind closed doors
and he left the house in 2001.

On later reflection, fashion commentators admitted
that the critics had treated McQueen poorly, with Lisa
Armstrong writing for *Vogue*: "When I look back I think it
aged pretty well…These things get very hyped up to create
a drama. It was a lot of pressure to put on such a young
person."

JULIEN MACDONALD

The appointment of Welsh knitwear designer Julien Macdonald as Givenchy's next creative director was another surprising choice, especially after the less-than-successful tenure of Alexander McQueen, for whom Macdonald had once worked as an intern.

Nicknamed the "Welsh Donatella Versace", Macdonald had worked as head of knitwear design for Chanel for two years. He had been headhunted by Karl Lagerfeld, who was impressed by his final-year student show. But his focus on reinventing traditional knitwear as minidresses made from star-spangled viscose and lurex, and his love of the celebrity lifestyle, left commentators scratching their heads as to how he would fare at a traditional couture house.

On announcing his appointment, Givenchy president Marianne Tesler released an optimistic statement: "His design sensibility is very representative of the Givenchy woman: classy, modern, elegant, sexy and feminine."

And Macdonald himself confirmed: "I wanted to go back to classic ideals of Parisian elegance."

The designer's first couture show was well received, with the only criticism being that it was a little too cautious. Macdonald had made the most of the expert atelier: the quality of the clothes was impeccable. The collection featured a modern, sheer version of the iconic "Bettina" blouse from Givenchy's own debut collection in 1952, and a series of elegant outfits in a neutral palette. Highlights included a pale velvet coat embroidered with sheared mink and crystal beads, cigarette pants, floaty muslin shirts and a modern take on the tulip-skirt silhouette Givenchy himself had pioneered.

Macdonald had clearly mined the house archives for historical references, including nods to Hubert de Givenchy's love of fur, feathers and adornment. This was a clever approach, tying in

GHT Knitwear
esigner Julien
acdonald,
cknamed the
elsh Donatella
ersace for his love of
stentatious glamour,
ok over from
exander McQueen
Givenchy in 2001.
s early designs,
ch as this tailored
hite dress with its
ademark latticework
atures, accessorized
a wide-brimmed
t, promised to
mbine the elegance
Givenchy with
acdonald's love of
ollywood glamour.

LEFT Macdonald produced some dramatic couture designs for Givenchy such as this frothy black floor-length gown, slit high on the leg and finished with an almost bondage-style face covering that was reminiscent of his predecessor, Alexander McQueen.

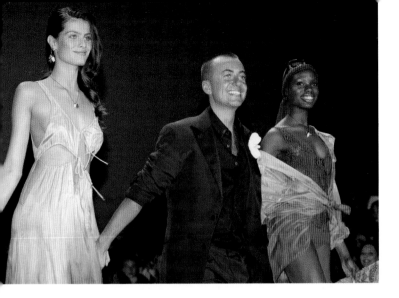

ABOVE These bright cutaway designs from his Givenchy Spring/Summer 2004 collection are typical of Julien Macdonald and were reasonably successful commercially. However, his two-year-tenure ended soon afterwards.

with Macdonald's own love of Hollywood glamour. Initially things looked promising for the young designer if, as *Vogue* put it in the show review, he could pull off "a touch that was both more assertive and light-handed."

Unfortunately, Macdonald failed to live up to expectations. His next few collections received poor critical reviews, although commercially the 1950s-style skirt suits, black cocktail dresses and revealing red carpet-worthy gowns were fairly successful.

Macdonald's contract was terminated after two years. At the time, it was suggested that the pressure of working for such a prestigious Paris fashion house led to this decision. The designer himself acknowledged the demands of the role in the BBC documentary *On Show, A Welshman in Paris*: "It looks incredibly fab and glamorous from the outside but the inside and the reality is very different. It takes up almost every minute of my entire life."

Macdonald returned to London to concentrate on his own label, with a vacancy opening up once again at Givenchy.

RICCARDO TISCI

Rumour has it that when Riccardo Tisci was interviewed for the creative director role at Givenchy, he was the only candidate who didn't mention Audrey Hepburn. Whether this sealed the deal or whether he was appointed in spite of it, the little-known, 30-year-old Italian designer, with his gothic sensibility, seemed yet another risky choice for the fashion house.

Tisci's first couture collection, for Autumn/Winter 2005, was not shown on the catwalk but on models posed statue-like throughout the rooms of the House of Givenchy. The clothes embodied Tisci's trademark dark romantic style, most discernable in the long, swagged dresses and his use of velvet and chiffon, but also in the styling of the models, with their long, centre-parted hair. Luckily, the looks were imbued with sufficient Parisian chic to make the edgy clothes appealing to Givenchy customers.

Writing for *Vogue*, Sarah Mower declared Tisci promising and the collection "less aggressive than McQueen and less vulgar than Macdonald."

Vanessa Friedman also gave her seal of approval in the *New York Times*:

"Mr Tisci managed to combine his own harder-edged sensibility with a certain French classicism and a dose of emotion to give Givenchy a newfound relevance: He made crosses, skulls and the perfect white shirt make sense."

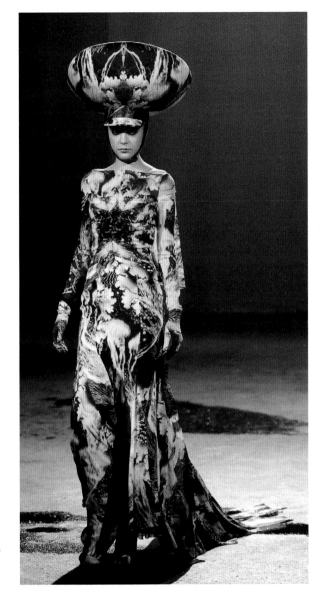

RIGHT Riccardo Tisci was a relative unknown when he joined Givenchy, but his unique blend of dark romanticism and Italian glamour proved an excellent fit for the fast-evolving fashion house. This unique silk chiffon dress for its haute couture Spring/Summer 2007 show features an imposing, edgy print.

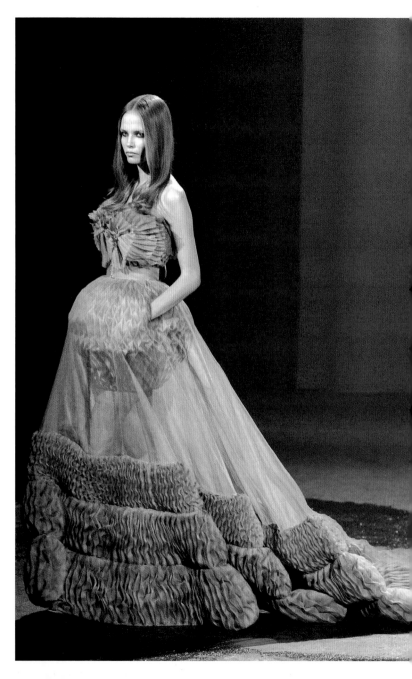

Less auspiciously, Tisci's first ready-to-wear collection was condemned by critics as "painful". But the designer learned his lesson, and by Autumn/Winter 2006 the fashion press viewed him as the brand's potential saviour. Here was a creative director who could draw on the heritage of Givenchy with confidence, yet was not afraid to add his own modern, playful twist.

Tisci was also prepared to tackle important issues such as the lack of diversity in the fashion industry. His decision to open a show by sending down the runway six consecutive women of colour echoed Givenchy's choice of house models during the 1970s. Tisci continued to champion diversity, selecting Black models such as Joan Smalls and Jourdan Dunn. He was the first designer to book a transgender woman for one of his advertising campaigns.

Onlookers continued to cautiously applaud Tisci over the next couple of years, admiring his work while acknowledging the enormity of his task as a young newcomer to the rarefied world of Paris haute couture. Critiquing his Spring/Summer 2007 couture show, Sarah Mower observed: "Tisci obviously aspires to say something personal and poetic with his work, and his melancholic and romantic nature is beginning to come into focus." She went on: "What Tisci needs most is the confidence not to try too hard to fit in with the old guard… When a young designer finds the strength of his own voice, the world will listen, and Tisci should be encouraged to do just that."

Mower's advice proved prescient. Tisci proceeded to find his own path at Givenchy. His Autumn/Winter 2007 couture collection, his first collection at the fashion house to be presented on a traditional catwalk, was a riot of animal skins and feathers, leather corsetry and immaculately cut draped spiral dresses. It looked back to the Greek goddesses of the hunt and forward to a space-age future and embraced the 1980s with bondage motifs, spiked shoulder pads and decadent, oversized fur coats.

OPPOSITE Tisci reinvents the red carpet gown here by working reams of folded organza, including an underskirt which is just visible through the transparent mid-section of the dress. The hint of a smaller, racier dress within is masterful, as is referencing the signature Givenchy bow motif with an origami-like bodice.

Tisci's ready-to-wear collections, which featured contemporary tailoring, elegant blouses and cleverly cut, understated dresses, proved a commercial success. However, it wasn't until the late 2000s that his design talent was fully translated onto the catwalk. For once, his subtly gothic romanticism was in tune with what the rest of the fashion industry was doing. His Spanish-influenced, toreador-style jackets, frill-fronted blouses and urban utility leather puffer jackets were a welcome addition to his tailored separates.

Despite a slight misstep in the form of bodycon dresses, unenthusiastically dubbed "Western bondage" by commentators, Tisci soon returned to form. For inspiration, he looked to the work of Elsa Schiaparelli, who, of course, had once inspired the young Hubert de Givenchy to follow his own instincts as a designer.

Backstage at his Autumn/Winter 2009 show, Tisci announced:"I wanted to show lots of different shapes for all kinds of women."

His sentiment harks back to Givenchy's own determination to make clothes fit a woman's body, rather than the other way around.

In the couture collections that followed, Tisci revealed an increasingly sure hand with the intricacies of high-end fashion, including techniques that had become his signature, including dégradé (where the colour of a fabric fades like a sunset), lacework and fringe-work. His tailoring reached new heights of expertise and his clothes epitomized contemporary urban chic. *Vogue* applauded Tisci on proving his credentials as a designer, "…bringing a much-needed sense of modernity to an old tradition."

Often created in a monochrome colour palette, or in black and gold, Tisci's clothes were adorned with the flounces, feathers

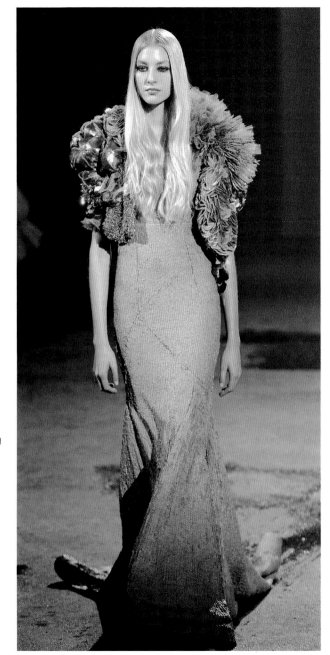

RIGHT This particularly stunning bronze sequin-covered sheath with a fishtail finish and matching cape combines ruched organza, petals, pleats and organic floral sequin embellishments that sparkle as they catch the light. It is typical of Tisci's romantic leanings.

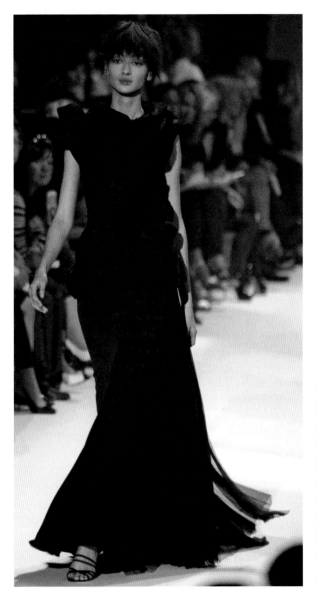

LEFT This black outfit from Autumn/ Winter 2008, made from sumptuous velvet and net, two of Tisci's favourite fabrics, might have subtle overtones of goth about it but nevertheless is an example of the eminently wearable and glamorous clothes designed by the Italian for Givenchy.

and other decorative touches that Givenchy himself had so loved. There was no shortage of glamour, either, and by Spring/Summer 2010 Tisci was beginning to introduce the high-octane outfits that lured in an important new type of celebrity client.

Once again, Sarah Mower hit the nail on the head:

A vivid glam-rock electric blue and green mosaic-embellished jumpsuit and skirt were the kind of jarring, risk-taking pieces that are guaranteed to be… taken up by the new fame-seeking music-business generation that recognizes high fashion is a sure way to get noticed."

The pieces created by the Givenchy atelier under Tisci's direction became ever more breathtaking. For Spring/Summer 2011, a single outfit required 2,000 hours of cutting and 4,000 hours of sewing to come together. Tisci had always referenced his Catholic heritage in his collections. Now, he blended this influence with inspiration from Japan, including futuristic robot toys. His pieces, many featuring feather embellishments and wing motifs, were presented in the style of an art installation. Writing for *Vogue*, Tim Blanks singled out: "A bolero that crossed a robot's face with a Catholic cross… organza that was laser-cut and appliquéd on layers of chiffon and tulle to create a three-dimensional spread of vermilion wings."

By 2012, Tisci had reached a point in his career when he could begin to reflect on and rework his previous creations. "To me, the mark of a successful designer is having an identity," he said.

Tisci's now-characteristic approach to details, especially beaded fringing, was already influencing the wider fashion scene. His ready-to-wear collections were increasingly following the lead of his haute couture creations, demonstrating an unusually high level of craftsmanship and attention to detail, and drawing on global inspirations. He continued to introduce more athleisure, a fast-growing market among high-end luxury designers, and in 2016, he announced a collaboration with the sports giant Nike, on a collection of tracksuits and trainers.

Tisci's ability to keep his finger firmly on the pulse, his ease with the Instagram generation and his obvious talent and likeability within the notoriously back-stabbing world of fashion turned around Givenchy's fortunes. A broad spectrum of celebrities and socialites, including the Kardashians, Beyoncé, Meryl Streep, Marina Abramović and Madonna, flocked to the newly revitalized fashion house.

Womenswear aside, the arena in which his ability to blend tradition with street style has been most successful, particularly among critics, is his menswear collections. For decades, Givenchy menswear had remained in the shadows, less successful than its fashions for women, until 2004, when British tailor Ozwald Boateng was brought on board to revitalize the line. His tenure was not a success and in 2007 he left the house, where the in-house team took over before handing the reins to Tisci in 2009, making him the first creative director to have full control over both women's and menswear at Givenchy.

Tisci's tailoring skills, honed over his years of designing couture, served him well, especially in his eveningwear offerings. So did his penchant for layered streetwear, with stylings such as

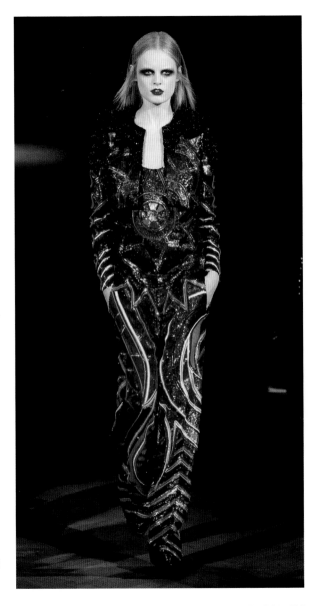

RIGHT Electric colours and a retro disco vibe emerged in 2010. This bright blue jumpsuit with matching cropped bolero printed in graphic lines and covered in sequins is somewhat reminiscent of a David Bowie stage outfit.

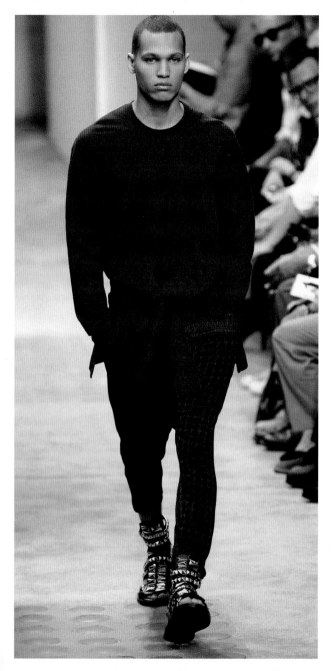

LEFT Tisci not only put womenswear at Givenchy back on the fashion map, he also transformed its menswear with offerings such as this red outfit, with printed trousers and stud-motif gladiator-style sandals.

shorts worn over leggings, albeit ultra-stylized ones made from ruched leather, or elaborately laced.

As the 2010s progressed, Tisci's menswear went from strength to strength. His winning combination of sportswear and street styles, resulting in a kind of high fashion hip-hop, grabbed the headlines. Meanwhile, he retained Givenchy's traditional tailoring, which brought in a steady flow of customers attracted by its quiet sophistication. Tisci's designs reached a new audience when big-name celebrities started to wear his clothes. For example, Kanye West memorably appeared on stage in one of the designer's trademark skirts, an adaptation of the warrior kilt.

At the beginning of 2012, Tisci jubilantly exclaimed: "Now I recognize 100 per cent who my man is." That man, as *Vogue* noted in their Autumn/Winter 2021 commentary, might equally choose "a striped top studded with red enamel stars, or a denim baseball jacket paired with a matching skirt… Or he could choose the lush solemnity of the all-black ensemble that opened the show: a double-breasted suit, a shirt."

In February 2017, riding high on his success, Riccardo Tisci made the surprise announcement that he was leaving Givenchy. At the time, the designer said that he wanted to "focus on my personal interests and passions," but a year later, he took over from Christopher Bailey at Burberry.

On announcing Tisci's departure after twelve years in charge, Bernard Arnault released a statement summing up the designer's achievements at Givenchy: "The chapter Riccardo Tisci has written with the House of Givenchy represents an incredible vision to sustain its continuous success, and I would like to warmly thank him for his core contribution."

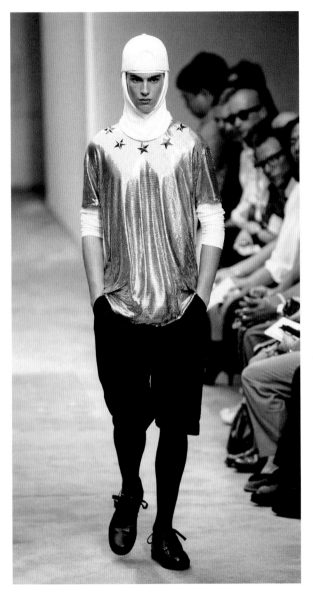

LEFT Tisci boldly uses gold with a star motif to give this streetwear outfit from Spring/Summer 2010 a twist, showing his masterful command of menswear.

OPPOSITE Dynamic prints, streetwear silhouettes and clever tailoring are all combined in this black and white outfit from Spring/Summer 2010, showing Tisci's masterful command of the menswear fashion scene.

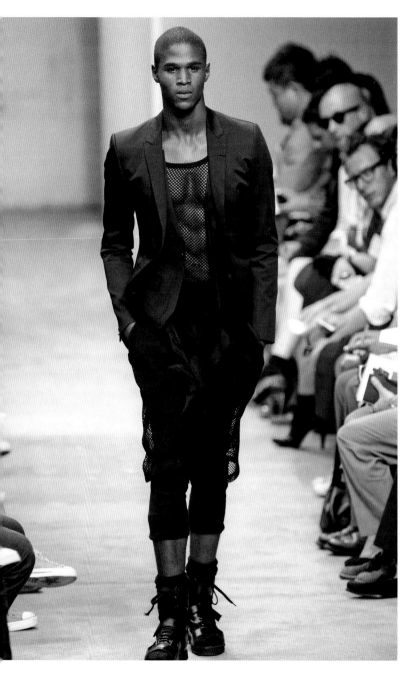

CLARE WAIGHT KELLER

In 2017, British designer Clare Waight Keller took the helm at Givenchy. Previously the creative director at Chloé, she was the first female designer to head the team at Givenchy. On her appointment, Waight Keller stated:

"Hubert de Givenchy's confident style has always been an inspiration, and I am very grateful for the opportunity to be a part of this legendary house's history."

Fashion commentators eagerly awaited her first collection, curious to see how her aesthetic, dubbed "bohemian with a sporty side of tomboy", by *Vogue*, would affect the Givenchy brand.

She had big shoes to fill: the House had achieved a strong stylistic identity and renewed commercial success under Riccardo Tisci's reign.

Waight Keller's first ready-to-wear show, for Spring/Summer 2018, delved deep into the Givenchy archives, drawing on original sketches and previous collections. Her work echoed Hubert de Givenchy's love of graphic print, his monochrome palette enlivened by pops of colour and a silhouette that emphasized the shoulders. Waight Keller had presented an accomplished collection, but critics noted that it lacked the excitement generated by her predecessor.

On the other hand, her exemplary couture collection showed that Waight Keller truly belonged at one of Paris's most

OPPOSITE Claire Waight Keller's debut show for Givenchy was Spring/Summer 2018. The designer echoed many of Givenchy archival themes such as bursts of colour in extravagant forms and textures. This outfit features an effusive feathered bolero which contrasts with a slim, elegant black satin skirt.

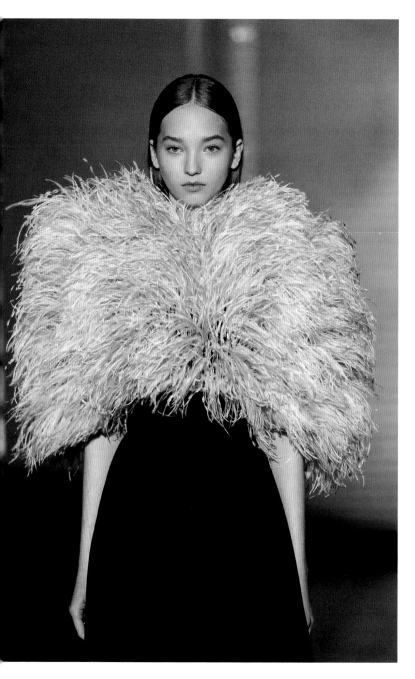

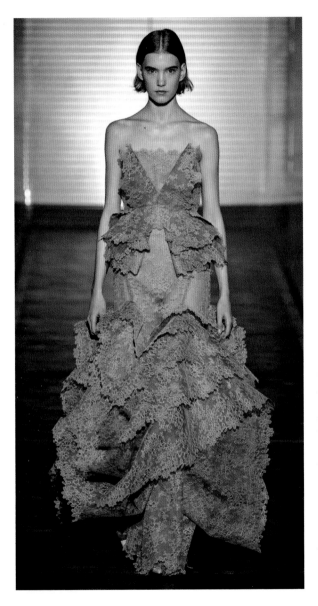

LEFT Waight Keller's aesthetic was more in line with Hubert de Givenchy's own than any of her predecessors. This glorious grey organza gown, covered in lace flowers, its bodice moulded into a shape evocative of Givenchy's peplum jackets and finished with an extravagantly pleated skirt, has a heritage air to it.

renowned fashion houses. All those hours spent immersed in the archives translated into the kind of exquisitely structured clothes that Givenchy himself had dreamed of, bringing a renewed elegance and dignity to the fashion house. As she put it herself: "I wanted to use the strength of tailoring, but in a feminine way."

The following year, Waight Keller took her inspiration for her ready-to-wear collection from Annemarie Schwarzenbach. Schwarzenbach was a bohemian Swiss author, photographer and traveller who was active in the early years of the twentieth century. Her gender neutral style and troubled life made her a gay icon after her tragic death in a biking accident aged 34. Schwarzenbach embraced androgyny a century before her time, sometimes taken as a man, other times as a woman by those she met.

Today, gender fluidity is an increasingly important consideration in fashion. Waight Keller stated that her intention was to "collide the codes" of womenswear and menswear. The designer created outfits inspired by photographs of Schwarzenbach, dressing tomboyish models in leather jackets tucked into army pants. The collection included men's tuxedo jackets and ultra-feminine, 1930s-inspired draped and bias-cut evening wear.

Despite designing for a French fashion house, Waight Keller remained quintessentially English in her design obsessions, such as her passion for the twentieth-century author Vita Sackville West's famous gardens in Kent. Fittingly, Hubert de Givenchy also loved flowers, as did his muse Audrey Hepburn, who liked to wear the designer's delicate floral-printed gowns.

Drawing on these creations for her Spring/Summer 2020 couture show, Waight Keller dubbed the designs "my own love letter to Hubert de Givenchy because I went into the archive

for this collection and looked into the history of the house from the very beginning."

Menswear was a new venture for Waight Keller, but one that she embraced wholeheartedly. In appreciation of its androgynous themes, *Vogue* posited that her collection

"seemed like a gender blend between Hubert de Givenchy and Audrey Hepburn, in those famous pictures of them casually strolling as friends along the Seine – when tailored flared trousers and belted trench coats were the quintessential Thing."

Waight Keller also excelled in the world of men's couture by concentrating on strong tailoring. She rejected the trainer and hoody vibe in favour of a more glamorous, almost dandified aesthetic.

Finally, the designer pulled off a coup when she was chosen to design Meghan Markle's dress for her marriage to Prince Harry in May 2018. The dress was pure heritage Givenchy. Later in 2018, dressed in a black, one-shouldered gown from the Givenchy haute couture collection, Markle presented Waight Keller with the prize for womenswear designer of the year at the Fashion Awards.

Despite Waight Keller's success at Givenchy, she decided to leave at the end of her contract, in April 2020, describing her time there as "three truly wonderful years".

Two months later, streetwear designer Matthew Williams was announced as the new creative director, marking a stark change in direction at the House of Givenchy.

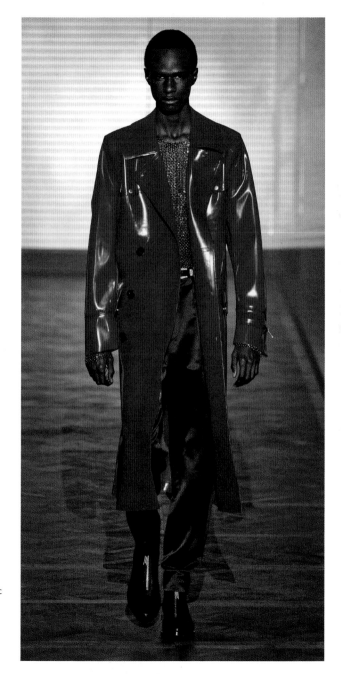

RIGHT Waight
Keller also took
Givenchy menswear
away from Riccardo
Tisci's streetwear
leanings back to
a more tailored
silhouette, keeping
shapes simple
while juxtaposing
different fabrics and
unusual textures. A
glossy electric blue
rubberized coat
is combined with
formal satin trousers
and a knitted metallic
mesh vest.

FASHION IN
A MULTIMEDIA
WORLD

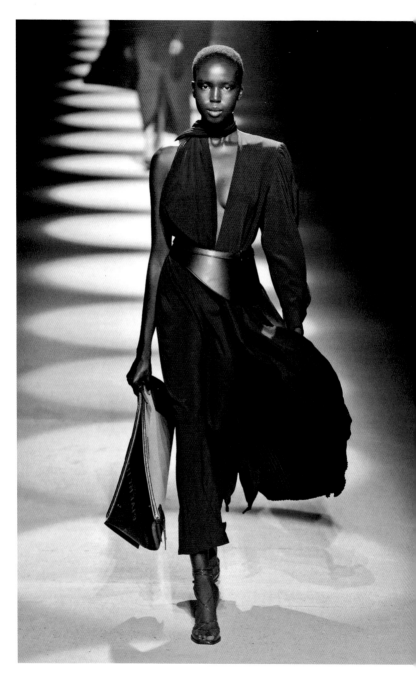

A MODERN CLASSIC

The appointment of American designer Matthew Williams as creative director of Givenchy was a bold move.

Not only did it mark an abrupt return to the luxe street aesthetic of the Riccardo Tisci years, it was also a deliberate attempt to cash in on Williams's personal image which began with pictures of the attractive designer tattooed and shirtless on the fashion house's social media. Most importantly for a brand whose fortunes had been resurrected, in part, by catering to a new social strata, Williams's pop culture and celebrity credentials were impressive.

An early collaborator with Kanye West, Williams was the creative brain behind Lady Gaga's stage outfits as well as being the singer's on-off boyfriend (she nicknamed him "Matty Dada").

Williams was also the founder of cult brand 1017 ALYX 9SM, which according to men's fashion bible *GQ* "blends the minimalist workwear ethos of Helmut Lang with a club-kid influencer spirit."

OPPOSITE Matthew Williams's background in streetwear and club and stage design translated into a sharper, cleaner aesthetic at Givenchy. In this outfit for example, the glamour is still there but the block colours and simple lines, accessorized by a large leather semi-circle belt, give the outfit a less fussy look.

As well as working on joint projects with brands including Supreme, Stussy and Nike, Williams was a key member of the streetwear collective BEEN TRILL alongside Virgil Abloh and Heron Preston.

On the release of Williams's first Givenchy collection for Spring/Summer 2021, the change in leadership was obvious. The old-school glamour of previous artistic director Clare Waight Keller, the first female AD in the history of Givenchy, was replaced with sharp, clean designs in block colours. William's self-confessed love of hardware as a jumping-off point for his clothes was evident in a range of lock jewellery. His inspiration was the Parisian trend for lovers to inscribe padlocks with their names and attach them to the bridges over the Seine, throwing the keys into the water to symbolize a love locked in place forever.

Williams is obsessive about fabric texture and finish, whether he's working with embossed crocodile leather, glossy evening wear or distressed streetwear. Rather than drawing on a particular thematic inspiration, Williams prefers a design process that is more deliberately commercial. As he told *Vogue*:

"I'm not a person who designs in themes. It's very much product-focused. A lot of it is what I would wear personally."

A brilliant exploiter of social media, the 35-year-old designer gave his debut collection a boost via Instagram selfies posted by his celebrity friends, including Kim Kardashian, the Jenner sisters, Julianne Moore and Laura Dern, which showed them posing in the new looks.

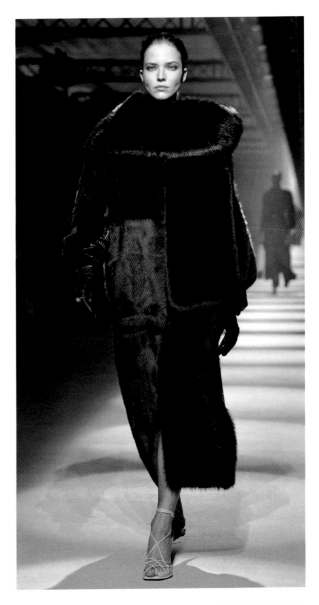

RIGHT Williams's obsession with luxe fabrics is obvious here for Autumn/ Winter 2021 in this slightly oversized faux fur coat in lusciously gradient tones of black, brown and burgundy. The blouson sleeves and cape-like effect are reminiscent of Givenchy's early lines, nodding to the heritage of the house.

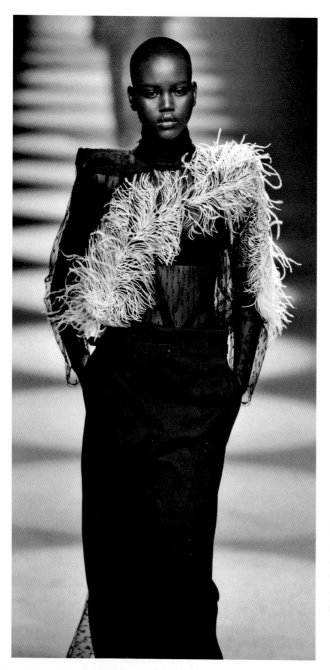

LEFT The classic Givenchy monochrome is given the Matthew Williams treatment in this outfit of a sheer black high-collared beaded blouse, with sharply angular shoulders tucked into classic tuxedo-style evening trousers. The white take on a feather-boa adds contrast and glamour.

Williams's deliberate use of celebrity Instagram to hype up his designs prior to his virtual show continued with his Autumn/Winter 2021 collection. The designs were showcased by Kim Kardashian, who posed in a figure-hugging olive-green jersey maxi dress, and Kylie Jenner in a pink logo-monogrammed dress. Illustrating the wide reach of Givenchy's appeal under its new leadership, Bella Hadid, Kate Moss and Anne Hathaway also posted pictures of themselves in the clothes, as did Venus Williams, wearing a black mesh top, peak-shouldered black overcoat and Williams's signature padlock necklace.

Williams has continued to push an industrial street aesthetic, with models in padded jackets and sculptural balaclavas, his occasionally hard-edged designs softened by oversized furry jackets. More often than not, embellishment is provided by his signature padlocks. The designer has upheld the fashion house's commitment to making women look their best, with a figure-skimming body-con column silhouette which harks back to Givenchy's Alexander McQueen era. Williams has said of his designs: "They're sensual and elegant and show female empowerment."

In his most recent collections, Williams has more openly acknowledged Givenchy's heritage by introducing throwback references, such as pearl embroideries on jeans which echo Audrey Hepburn's still resonant *Breakfast at Tiffany's* styling.

As a designer, Williams responds to the world around him, including the digital realm. He isn't afraid to incorporate the realities of how we dress into his designs, even in the rarefied atmosphere of haute couture. As he explained backstage after his Autumn/Winter 2022 ready-to-wear show: "With Covid, people have been wearing masks, so I've been exploring these balaclavas and gloves for that reason. It's almost a new archetype people are using in their daily lives."

In a world where brands need to constantly redefine themselves Williams is the perfect choice to cement Givenchy's reputation as a purveyor of modern classics in a fast-changing fashion landscape. In the words of *GQ* magazine:

> *"Williams is emblematic of a new breed of impresario, the DJ-designer-merch maker-cool hunter who is as fluent in savvy marketing as he is in fashion design. He is an expert at creating not simply the full look, but the whole visual universe, studded with characters, a killer soundtrack, the right accessories, and the best partners."*

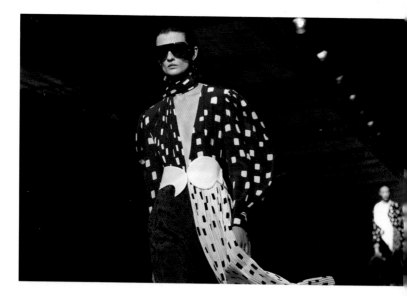

RIGHT As with many designers heading up luxury fashion houses who have embraced the streetwear aesthetic Matthew Williams has also blurred gender lines. This thoroughly contemporary outfit from the Spring/Summer 2022 womenswear with its oversized check tailored coat and graffiti-style imagery has an androgynous feel.

OPPOSITE This outfit from Autumn/Winter 2020 is pure modern elegance. Graphic prints combine with bold colour in a slash-neck blouson top which winds elegantly around the model's neck to extend beneath a sculptural white belt into a flowing pleated black and white printed train.

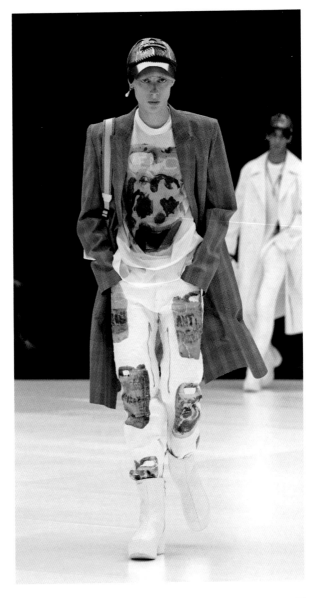

INDEX

CREDITS

The publishers would like to thank the following sources for their kind permission to reproduce the pictures in this book.